A N S W E R S

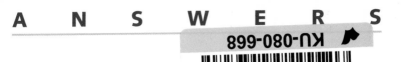

Orientation p. 7

The Alphabetical Guide and the Story of Vermeer contain a system of cross-references based on colors. The categories are indicated with a small colored recangle.

■ Work:
Subjects and
stylistic analysis

■ Milieu:
Painters, thinkers,
and family

■ Context:
Artistic trends and
techniques;
historical setting

The Story of Vermeer p. 11

By way of introduction, Vermeer's life and work are situated in their historical context. This overview touches on all the themes developed in the Alphabetical Guide.

Alphabetical Guide p. 31

In alphabetical order, the entries tell what you need to know to step into Vermeer's world. The information is enriched with detailed discussion of major paintings and highlighted sections explaining thematic, stylistic and contextual aspects of Vermeer's career.

Please note that entry titles have been marked with asterisks throughout this book; use them to look up historical details, artists, works, movements, etc.

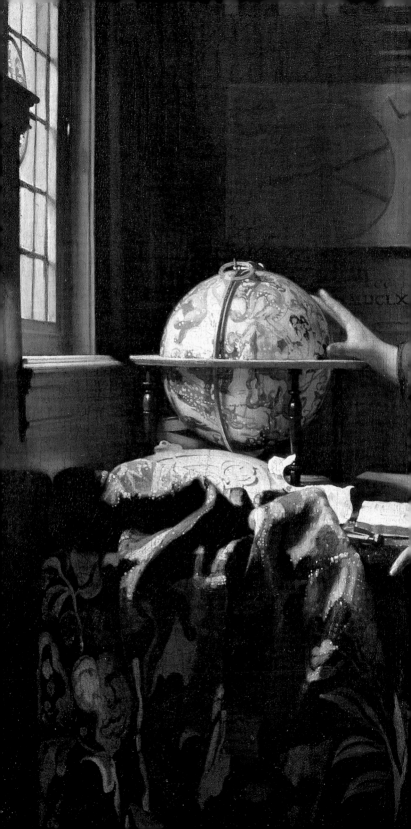

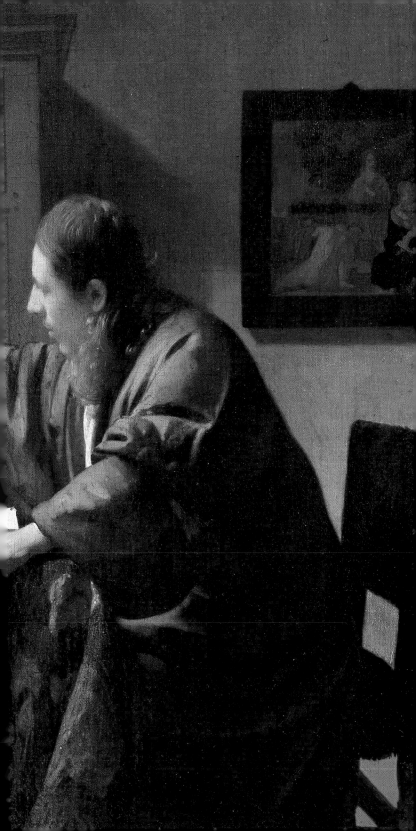

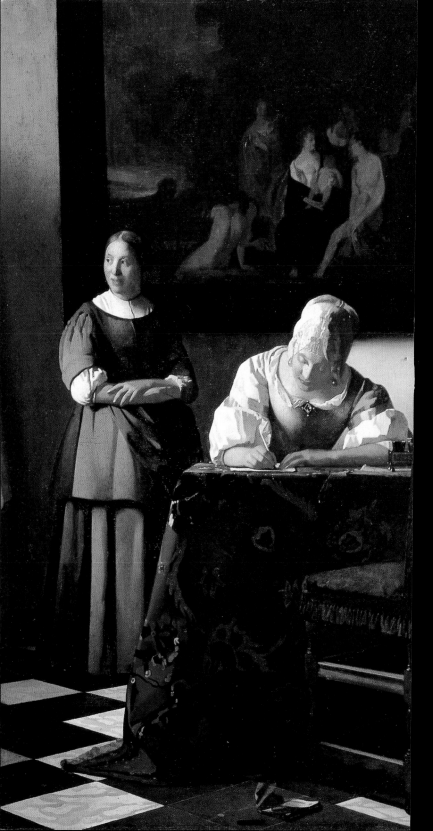

O R I E N T A T I O N

I. BIRTH OF A NATION

A. Life and Painting in Holland

In the aftermath of unrest (1566 to 1572) in the Spanish-ruled Netherlands, a Calvinist, business-oriented bourgeoisie brought new life to the United Northern Provinces. Independence in 1648 was followed by achievements and advances in the sciences, philosophy, and the arts.

- ■ *Bourgeoisie*
- ■ *Calvinism*
- ■ *Genre Distinctions*
- ■ *Iconoclasm*
- ■ *Local Centers of Activity*
- ■ *Maps*
- ■ *Netherlands*
- ■ *Orange, the House of*
- ■ *Religious Tolerance*

B. A Genius Out of Nowhere

Of humble stock, Vermeer, a Protestant by birth, converted to Catholicism at the time of his marriage to Catharina Bolnes. Despite the faithful support of his mother-in-law Maria Thins, and his patron, Pieter Claesz. van Ruijven, Vermeer was plagued throughout his life with financial difficulties.

- ■ *Accessories and Materials*
- ■ *Bolnes, Catharina*
- ■ *Buying and selling paintings*
- ■ *Furniture*
- ■ *Patrons and Commerce*
- ■ *Reynier Vermeer*

C. Delft, Heart of the Netherlands

Artistic activity reached a plateau in 1653 in Vermeer's native city of Delft, with painters such as Carel Fabritius, Paulus Potter, Adam Pijnacker, Pieter de Hooch, Abraham van Beyeren and Jan de Witte. A gradual decline took place after 1660, the year of Vermeer's acceptance into Saint Luke's Guild. By 1662 most of the major artists had left Delft.

- ■ *Caravaggio, Caravaggism, Caravaggesque*
- ■ *Delft*
- ■ *Dou*
- ■ *European Painting Trends*
- ■ *Guilds and Academies*
- ■ *History Painting*
- ■ *Local Centers of Activity*
- ■ *Modern Painting*
- ■ *Porcelain in Delft*
- ■ *Rembrandt*
- ■ *Still lifes*
- ■ *Vedutisti*

II. VERMEER, THE ENIGMA

A. Apprenticeship and Influences

Vermeer's six years of training remain a mystery. Was his teacher Carel Fabritius, Abraham Bloemaert, or Leonaert Bramer? Certain influences seem definite, including Gabriel Metsu's play of light, de Hooch's framing, Fabritius' perspective, Gerard ter Borch's format and verticality, and early on, the Caravaggesque style passed down by the Utrecht school.

- ■ *Apprenticeship*
- *Baburen*
- *Blomaert*
- *Borch, Gerard ter*
- *Bramer*
- *Bruggen, ter*
- ■ *Caravaggio, Caravaggism, Caravaggesque*
- ■ *Generation of 1650*
- *Hooch, Pieter de*
- ■ *Italy*
- *Metsu, Gabriel*
- *Sweerts, Michael*

B. Career Worries

Among the thirty-five Vermeer paintings recognized by the experts, only three are signed. Stylistic analysis allows us to trace the artist's development from Italian influence in the early paintings (1654–57) to pared-down final scenes (1662–75), via in-depth analysis of the properties of light in the middle period (1658–61).

- ■ *Astronomer*
- ■ *Christ in the House of Martha and Mary*
- ■ *Death*
- ■ *Faith*
- ■ *Girl with the Pearl Earring*
- ■ *Iconography*
- ■ *The Little Street*
- *Music and Musicians*
- ■ *Pearls*
- ■ *Prostitution*
- ■ *Self-portraits*
- ■ *Servants*
- ■ *Taverns and Sex*
- ■ *View of Delft*
- ■ *Wine*
- ■ *Woman Holding a Balance*

C. A Modest Output for a Handful of Admirers

Vermeer worked slowly and produced little. Certain of his paintings were probably commissions, while others were the fruit of his free expression. Regardless of subject-matter, the quality of Vermeer's output is a function of the endless innovations he introduced to accepted visual and stylistic vocabulary.

- ■ *Art Market*
- ■ *Curiosity Cabinets*
- ■ *Genre Painting*
- ■ *Patrons and Commerce*
- ■ *War of 1672*

III. A VELVET REVOLUTION

A. The Making of a Painting

The inventory of Vermeer's estate following his death provides only a brief account of the materials in his studio. Vermeer's choice of brushes, surfaces, preparatory measures and pigments have all been uncovered by research.

- *Accessories and Materials*
- *Art of Painting*
- *Color*
- *Furniture*
- *Materiality versus Perception*

B. Tradition and Innovation: Optics

Vermeer's work is an in-depth study of visual phenomena. Like a photographer, his aim is to express the different qualities of perception and focal points involved in the way we understand reality. Vermeer's studies in the nature of clarity may have relied on optical instruments such as the camera obscura in the preparatory stages of composition.

- *Camera obscura*
- *Dogs*
- *Gallant Conversations*
- *Hidden Symbolism*
- *Lacemaker*
- *Letters*
- *Light*
- *Mieris, Frans van*
- *Milkmaid*
- *Paintings within Paintings*
- *Windows*

C. Vermeer Forgotten and Remembered

The latent power of Vermeer's figures and his virtuoso handling of light brought new life to genre painting. The Dutch school in general reached its apogee in the 1670s. After Vermeer's death in 1675, however, painting in the Netherlands went into serious decline. Nearly forgotten in the eighteenth century, Vermeer's genius was rediscovered in the nineteenth century.

- *Forgeries*
- *Interiors and Privacy*
- *Lost, Found, and Discarded Paintings*
- *Proust*
- *Reputation*

All paintings are oil on canvas except where otherwise indicated.

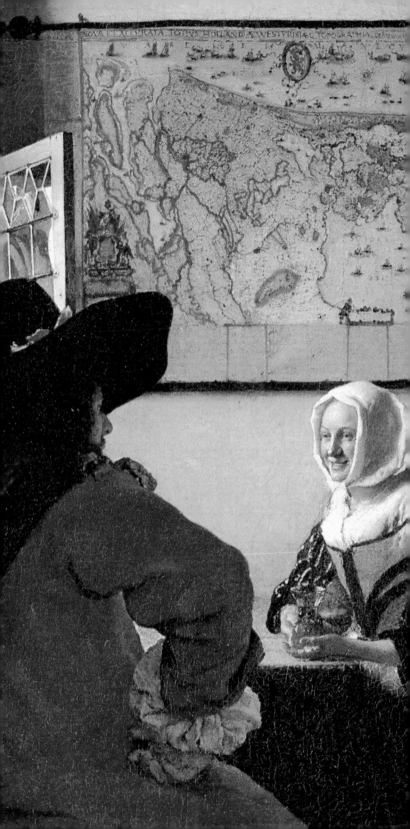

THE STORY OF VERMEER

Our fascination with Vermeer stems as much from the mystery that surrounds him as from the appeal of his paintings. Both the man and his work excite our curiosity. The canvases' long years of near-anonymity meant their rediscovery caused a sensation. There is also great appeal in the humility of this master who painted little, and whose brushwork provokes hours of awed examination.

I. Birth of a Nation
A. Life and Painting in Holland

Johannes Vermeer was born in Delft* in 1632. Holland was at that time the richest province of the Netherlands.* During the first half of the seventeenth century, the seven Northern Provinces which had successfully seceded from Spain in 1648 saw the rise of an enterprising, industrious bourgeois class, whose strength eventually overwhelmed absolutist aristocratic controls. The Southern Provinces (Flanders) remained under Spanish dominion. With a growing awareness of nationhood and maritime strength, scientific, intellectual and artistic activity in the North joined disciplines to create a new world view. Painters began to explore every imaginable aspect of visible reality.

The stylistic and thematic differences between art in the Northern and Southern Provinces are rooted in religion. The Iconoclastic* Revolt, fomented by the Protestant clergy in 1566, quickly spread, leading to destruction throughout the Netherlands, especially in Delft in August of that year. The destruction of art in the

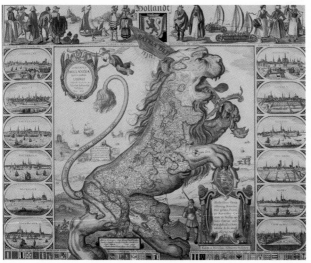

Nicholaes Johannes Visscher, *Map of Holland in the Shape of a Lion*, 1648. Maritiem Museum Prins Hendrik, Rotterdam.

churches of the predominantly Catholic southern provinces proved a boon to artists. Vast new construction projects brought "big business" to the Rubens workshop and others. In the North, however, the Protestant rejection of imagery in places of worship relegated painting to private patronage. Art became smaller in scale and began to depict profane topics (see Genre Distinctions) and Old Testament themes. Calvin's* writings called for artists to celebrate universal beauty and nature in all forms, thus encouraging "profane" painting. But the religious rift between the north and the south should not be overestimated. Vermeer's life itself is proof of the relative assimilation in place throughout the first half of the seventeenth century. Protestantism spread gradually, in a variety of forms, in this country where freedom and religious tolerance were fundamental values. Delft at first took a segregationist approach to Catholics. Vermeer, who apparently converted following his marriage to Catharina Bolnes,* lived with his family in Papenhoek, the "papist" neighborhood where the officially banned Catholic worship was permitted. With time, a degree of acceptance prevailed.

Egbert van der Poel (1621–1664) *Peasant Feeding Chickens.* 11 ½ × 14 ¼ in (29 × 37 cm). Musée du Louvre, Paris.

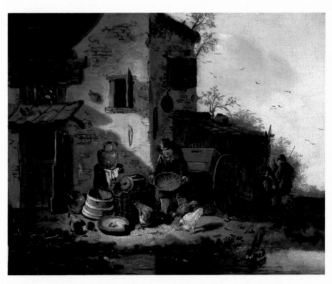

B. A Genius Out of Nowhere

Vermeer came from an undistinguished background. His father Reynier, hot-headed in his youth, started out as a master weaver. He bought an inn and took up hostelry, then in 1631 became an art dealer which was possibly a related profession at the time. This brought the father and most likely the son into contact with such

important painters as Balthasar van der Ast, a specialist of refined, archaizing still lifes, and the masters of night scene Egbert van der Poel and Leonaert Bramer, the best-known Catholic artist of Delft in the 1650s. In addition to these artistic discoveries, Vermeer developed socially through his marriage and thanks to the unfailing support of his mother-in-law Maria Thins. Vermeer also practiced his father's business. Selling paintings, including those by other artists, was not unusual for Dutch artists of the seventeenth century. Vermeer clearly attained a level of social freedom which exceeded his rise in material terms. The deep calm of his art in no way expresses the financial worries that troubled his family for generations before and after him. The inventory of Vermeer's worldly possessions upon his death was far more modest in terms of art holdings than Rembrandt's,* despite the latter's monetary problems, and attests to Vermeer's relative social immobility.

C. Delft, Heart of the Netherlands

Aside from the paintings and artists handled by his father, what was the the young Vermeer's artistic background? He seems to have traveled extensively, at least within his own country. In the Northern United Provinces of the Netherlands, particularly in Holland,

Leonaert Bramer, (1596–1674) *Pyramus and Thisbe.* Oil on copper, 18 × 23½ in (46 × 60 cm). Musée du Louvre, Paris.

the circulation of people as well as of art works was facilitated by the existence of developed urban centers and systems of transport, especially by river. One of the major artistic developments of the early seventeenth century was Caravaggism,* imported from Italy

Christ in the House of Martha and Mary, c. 1655. 63 × 55¾ in (1.60 × 1.42 m). National Gallery of Scotland, Edinburgh.

by such figures as Hendrick ter Brugghen (in Rome between 1604 and 1614). This influence was significant in the paintings of Gerard van Honthorst, Jan van Bronckhorst, Caessar van Everdingen, and Leonaert Bramer. Vermeer shows an affinity for van Honthorst in his *Christ in the House of Martha and Mary** (National Gallery of Scotland, Edinburgh). In two of his paintings, Vermeer represents a painting belonging to his in-laws by Dirck van Baburen,* close to ter Brugghen, who depicted more rustic themes in a similar style. Halfway through the century, an impressive number of painters were active in the cities of the Netherlands, with each urban center dominated by a central figure, for example Rembrandt in Amsterdam. When Rembrandt left Leiden for Amsterdam, his disciple Gerrit Dou founded the Leiden 'fine' painting style.

Artistic activity reached a peak in Delft in 1653, when the twenty-one-year-old Vermeer was admitted as master to Saint Luke's Guild. The porcelain* industry in Delft, begun in the sixteenth century, was at a high point, and a good many painters, including Jacob van Velsen, came from Delft, while others moved there, such as Rembrandt's

Gabriel Metsu, *Christ and the Adulteress,* 1653. 4 ft 4¾ in × 5 ft 5 in (1.34 × 1.65 m). Musée du Louvre, Paris.

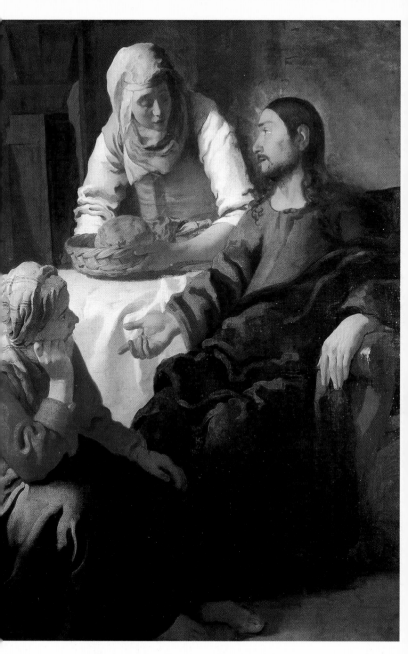

brilliant and original pupil Carel Fabritius, who assimilated the
master's teachings, while developing a more clear, clean and con-
strained style of his own. Fabritius and a model for his painting
died in the great gunpowder explosion of 1654. Paulus Potter, who
painted bright landscapes and animal scenes, was in Delft in 1646,
the year before executing his monumental *Bull* (Mauritshuis, The
Hague). Working in landscape along very different lines, Adam Pij-

nacker had returned to Delft from Italy by 1649. The role of light* in his work certainly attracted Vermeer's attention. Aside from the artists who frequented Reynier* Vermeer's shop, Pieter de Hooch, Abraham van Beyeren (who depicted marine scenes and still lifes) and Emmanuel de Witte (who painted everything from church interiors to fishmongers) were all present in Delft. Unlike Vermeer, many of these painters were to leave Delft: de Hooch, van Beyeren, and de Witte were gone by 1662 when Vermeer was elected to Saint Luke's Guild.

II. Vermeer the Enigma
A. Apprenticeship and Influences

Vermeer's apprenticeship,* the six compulsory years leading up to guild membership, remains a mystery. Close examination of his earliest works and archival information suggest several possibilities. In addition to the widely-recognized Fabritius hypothesis, there is Albert Blankert's theory based on distant family relations and a Caravaggian influence in the artist's early paintings. It holds that Vermeer probably studied with Abraham Bloemaert* in Utrecht. It has also been speculated, with documented evidence of family ties, that Vermeer's teacher was Leonaert Bramer. While there is no apparent trace of Bramer's style in Vermeer's work, the disparity between the Bosch-like Jan Mandijn and his student Bartholomaeus Spranger, or the archaizing Tobias Veraecht and his illustrious student Peter Paul Rubens, is worth keeping in mind. In terms of visual evidence, the savior of Vermeer's *Christ in the House of Martha and Mary**(page 15) seems to refer to a painting by Erasmus Quellinus (Musée des Beaux-Arts, Valenciennes), while on a more subtle level Gabriel Metsu's *Christ and the Adulteress* (page 14) is a less refined forerunner of Vermeer's stylistic play of light, with its alternate highlighting and flattening effects.

Vermeer apparently took an interest in experiments in spatial representation during the 1650s. This research gave rise to the development of panoramic city views, Pieter de Hooch's close-ups of streets and interior courtyards, exercises in perspective by Samuel van Hoogstraten and Fabritius (*View in Delft, with a Musical Instrument Seller's Stall* (National Gallery, London; page 108–9), as well as the metamorphosis of interior* scenes. Blankert intelligently remarks that with Gerard ter Borch,* the horizontal format and almost monochromatic group representations are definitively abandoned in favor of vertical depictions of one to three figures. The-

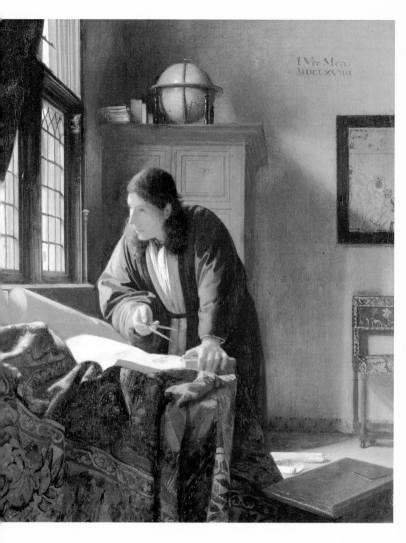

matically, painting moves from busy gatherings to intimate settings where, aside from occasional love-related moral allusions, nothing eventful occurs.

B. Career Worries

Of the thirty-five works generally attributed to Vermeer by the critics, only three are dated: *The Procuress* (1656, page 106), *The Astronomer** (1668, page 36–7), and *The Geographer* (above). Although the last two works are unmistakable masterpieces, doubts have been voiced as to the dates' authenticity. Vermeer's indifference to dating and even to signing his paintings is indicative of his

The Love Letter,
c. 1669–70.
17 ⅜ × 15 ⅛ in
(44 × 38.5 cm).
Rijksmuseum,
Amsterdam.

18

relative detachment. Through stylistic analysis, Vermeer's production can be divided into three main categories. The earliest canvases—including *Diana and her Companions* (page 32–3), *Christ in the House of Martha and Mary** (page 48–9), *St Praxedis* (page 82), and though the attribution of this last work is contested, *The Procuress* —display a receptivity to other artists' work. An Italian influence is apparent in blonde Diana's Venetian beauty. Venetian painting made up the bulk of Italian art in the Netherlands at the time, and Vermeer might have been particularly familiar with this work, as his expertise was enlisted to authenticate the Italian paintings in the Elector of Brandenburg's collection in 1672. A second influence was Caravaggio, whose style was assimilated in the work of the Utrecht artists. Already evident in *Diana and her Companions,* the affinity is combined with traditional Antwerp satirical repertory in *The Procuress.* Among other influences, the highly original painter Michael Sweerts* is worth mentioning.

Woman with a Lute, 1662–63. 20 ½ × 18 in (52 × 46 cm). The Metropolitan Museum of Art, New York.

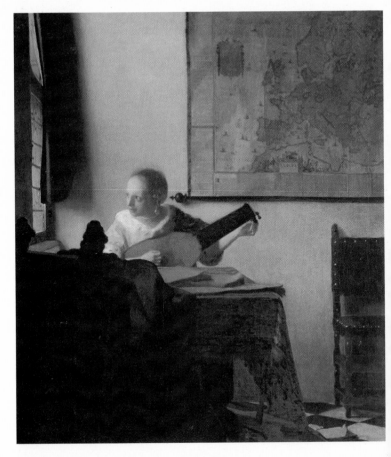

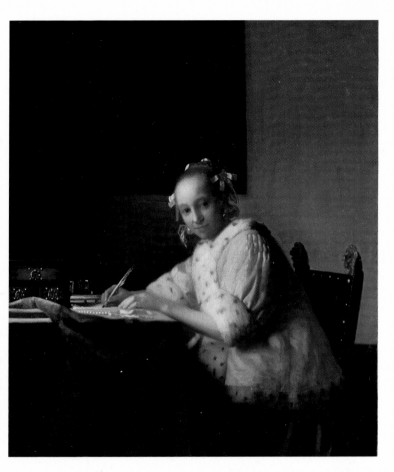

In the second period of his career, roughly from 1658 to 1661, (*Officer and Laughing Girl*, page 42–3; *The Milkmaid*,* page 86–7; *The Little Street*,* page 80–1) Vermeer develops his interest in the properties of light and their interaction with textures, both interior and exterior, using a thematic vocabulary akin to that of Dou, ter Borch, Metsu, and Maes. However, as Blankert points out, it would be a mistake to evaluate an artist's career in terms of successive influences alone. As with ideas, certain themes, stylistic dispositions, and tendencies can manifest themselves simultaneously in different locations. Such widespread trends quickly became commercial formulas typical of artistic production in the Netherlands from the fifteenth century on.

Vermeer's third phase, beginning around 1660 with such works as *Woman Holding a Balance* (page 114–15), *Woman in Blue Reading a Letter* (page 78), and *Woman with a Lute* (facing page), is

A Lady Writing, c. 1665. 17 ¾ × 15 ¾ in (45 × 39.9 cm). National Gallery of Art, Washington, DC.

21

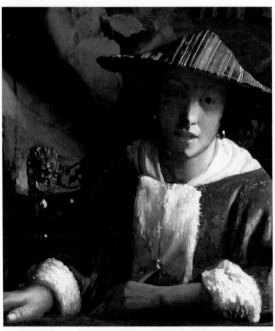

Girl with a Flute, c. 1665–70. Oil on wood panel, 7 ¾ × 7 in (20 × 17.5 cm). National Gallery of Art, Washington, DC.

characterized by a simplified setting, with figures that seem to be instantly captured, in snapshot fashion, and a presence of light* which could almost be described as the main theme. The portraits, of which *The Girl with the Pearl Earring** (page 66–7) is the best known, are also from this period. The canvases considered to be Vermeer's last—*The Guitar Player, The Love Letter* (page 18–9), *A Lady Standing at the Virginal* (page 94–5), and *A Lady Seated at the Virginal* (page 39)—are often thought to betray a lack of substance and loss of inspiration on the artist's part. These works may be the result of restrictive commissions accepted during a trying period.

C. A Modest Output for a Handful of Admirers

The iconography* of Vermeer's individual canvases is strongly influenced by their status as commissioned works. A painting produced for a client, such as the *Allegory of Faith* (page 58–9), lends itself more readily to an interpretation based on traditional parameters than a naturally more innovative canvas executed in accordance with the artist's wishes and inspiration alone. Vermeer's approach seems generally to have been the latter, confining his work to appreciation by a handful of admirers only. Along with his slow work pace, this individualistic perspective on artistic creation was at odds with the production methods of many of his Northern European contemporaries, and might explain a number of the difficulties Vermeer encountered. However, Vermeer was by no means rejected by his contemporaries. He was accepted into the painters' guild at a very young age, albeit with some difficulty in paying his dues, and was twice selected as representative of the guild by his colleagues.

III. A Velvet Revolution
A. The Making of a Painting

*The Art of Painting,** dated 1665, depicts the symbolic raised curtain in the foreground. The background is graced by a map of the seventeen provinces of the former Netherlands, after the Union of Utrecht of 1579 and before the decisive signing of the Treaty of Munster in 1648, when the Northern Provinces finally separated from Spain. The painter's attire, which dates from the same period, may express Vermeer's nostalgia for a world more favorable to artists than the bourgeois society of the northern Netherlands. A model with the traditional characteristics of the muse Clio, perhaps symbolizing Fame, stands in front of the map. The artist is seated at his easel. He is seen from behind, working on a half-figure representation of the woman. His canvas has been traced with a sketch of white lines on a prepared gray-brown surface. Such a drawing in chalk or pigment might be directly covered with paint in the next step of execution. However, the existence of these materials is not discernable by the infrared reflectography commonly used to document underlying drawing. The inventory following Vermeer's death gives a brief description of the contents of his studio. Little is made of the fact that alongside the canvases and tools there were "six panels" which would indicate that Vermeer painted on wood as well as canvas. The argument against a wood painting surface is sometimes used to refute the authenticity of the *Girl with a Red Hat* in the National Gallery, Washington, DC.

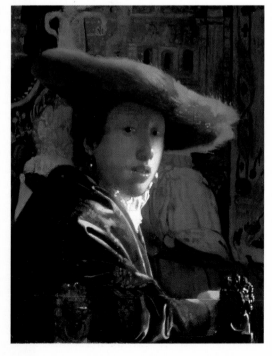

Girl with a Red Hat, c. 1665. Oil on wood panel, 9 × 7 in (22.8 × 18 cm). National Gallery of Art, Washington, DC.

In 1968 the results of laboratory analysis of thirty Vermeer paintings were published by Hermann Kühn. Aside from the

Girl with a Red Hat and the *Girl with a Flute,* also at the National Gallery, all of Vermeer's recognized works are on canvas. Vermeer prepared the canvas surface with a thick layer of white, sometimes lightly tinted yellow, brown, gray, or with color, as in the *Art of Painting*. Vermeer's pigments were those used by Netherlands artists of his time: lead white, lead-tin yellow, yellow and red ochres and vermilion or madder lake reds, earth for the browns, a mix of blue and yellow or earth for green. Vermeer's favorite color* and pigment were blue and ultramarine, extracted from the semi-precious lapis lazuli stone. Only once, in *Christ in the House of Martha and Mary,* did Vermeer use indigo for his blue, possibly due to limited financial means at this early point in his career. Vermeer's consistent and lavish use of the expensive lapis lazuli-based color is evidence of an insistence on quality and reflects the works' market value.

B. Tradition and Innovation: Optics

Vermeer's choice of techniques and materials represent a world view often regarded by twentieth-century historians as the expression of his interest in the philosophical preoccupations and scientific innovations of his day. Anthony van Leeuwenhoek, the great scientist who contributed to the development of the microscope, was named executor of Vermeer's estate by his widow. But this arrangement was financial in nature and does not prove the existence of friendship or common intellectual or aesthetic concerns between the two men.

Vermeer's art demonstrates unfailing interest in visual phenomena, which took precedence for him over the dictates of the Dutch tradition of microscopically clear and uniform representation. This artistic ideal, already attained by Jan van Eyck in the fifteenth century, reached a second apogee in the 1660s with painters such as

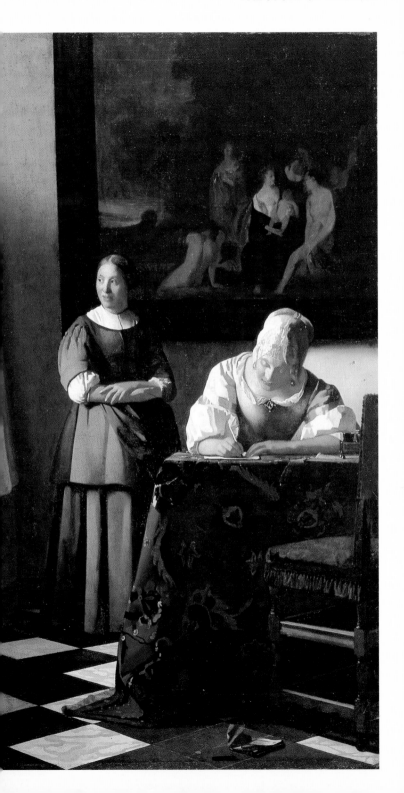

Preceding
page: *Lady
Writing a
Letter with
her Maid,*
c. 1670.
28 ½ ×
23 ½ in
(72 ×
59.7 cm).
National
Gallery of
Ireland,
Dublin.

Gerrit Dou and Frans van Mieris.* From the start, Vermeer manifested an indifference to this quest for an increasingly minute depiction of reality. His influences were primarily from Rembrandt by way of Carel Fabritius, and from the Italian painters introduced by Utrecht artists. These influences tended against strict fidelity to the model. Vermeer explored visual effects by multiple picture planes, for example in his *Procuress* (page 106) where little white tassels direct the viewer's gaze by interrupting the dark expanse of the coat in the left foreground.

Alongside these elements modulating the picture plane, Vermeer's great innovation is a pictorial realization of the fact that the eye's focus is uneven and relative. The degree of sharpness accordingly varies along a painting's planes and the defining objects and markers that capture the light. This accounts for the contrast between an often blurred foreground (such as the red and white threads and the sewing box pompon in *The Lacemaker**), one or two middle ground figures in semi-focus, and a far wall—with its crevices and nails casting shadows—that provide the real focus, directing the viewer's gaze to the background. This filling of space appears to correspond to a sort of fear of the void in Dutch art. Only the portraits and *Mistress and Maid* (page 103), with their dark backgrounds, break with this custom.

There is no way to prove whether or not Vermeer used a camera obscura* to obtain his optical effects, and no such item is recorded in the artist's inventory. Other instruments, including lenses, may have been used by Vermeer, who was certainly at least aware of the progress being made in optics in the Netherlands.

C. Vermeer Forgotten and Remembered

In addition to its correspondence to technical and scientific innovations, Vermeer's art presents a new perspective on certain themes, particularly the simplifying and softening of genre* painting conventions. The sheer quantity of genre scenes produced in both the northern and southern Netherlands made for monotonous output in Vermeer's time. Vermeer's settings are in fact highly uniform. They present a window* or light source at the left that illuminates, pervading the objects and figures depicted. This concern with illumination appears early in Vermeer's career and is present for example in *A Maid Asleep* (page 28–9) whose subject matter he possibly borrowed from Rembrandt's pupil Nicolaes Maes. Vermeer transforms the theme with a foreground still life* and luminous effects

such as the edge of what appears to be a backwards-facing mirror on the chair to the right, and with the strip of golden light along the doorframe. Vermeer's figures appear frozen in an instant that is free of anecdotal development, often turned to the window as if transfixed by the light. After Rembrandt's use of introspection, their serene perfection takes on a cosmic dimension (*Woman with the Pearl Necklace,* page 96).

The richness, diversity, and technical perfection attained by the Dutch school in the 1670s was extraordinary. But the difficult economic and political circumstances after the War* of 1672, which directly affected Vermeer and his family, added to a relative thematic stagnation, and an awareness of Rembrandt's overwhelming genius, contributed to a period of crisis in the painting of the northern Dutch provinces. The art or rather the name of Vermeer was largely forgotten in the eighteenth century. However, the French critic E. J. T. Thoré (Thoré-Bürger), art historians and writers such as Marcel Proust* revived it in the nineteenth century. From the start Vermeer was not favored by circumstance. His slow productivity (twenty of his paintings have been lost over the years) and his disregard for conventions and fashion limited the range of his potential admirers. Thus the bulk of his work ended up in the hands of only a few collectors. In 1683 the bookseller Jacob Abrahamsz Dissius owned twenty or twenty-one Vermeers, and these were dispersed by a sale in 1696. A period of obscurity was followed by the fascination which lead to van Meegeren's famous forgeries.* Only today is Vermeer accorded his place among the greatest artists of all time. His placid yet deeply innovative paintings opened artistic horizons which would not be fully explored until the nineteenth century, for instance by Corot.

Patrick LE CHANU

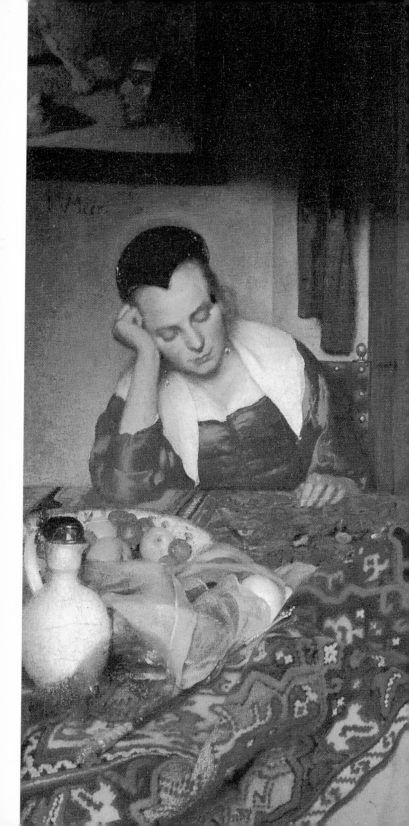

A Maid Asleep, c. 1657. 34½ × 30⅛ in (86.5 × 76 cm). The Metropolitan Museum of Art, New York.

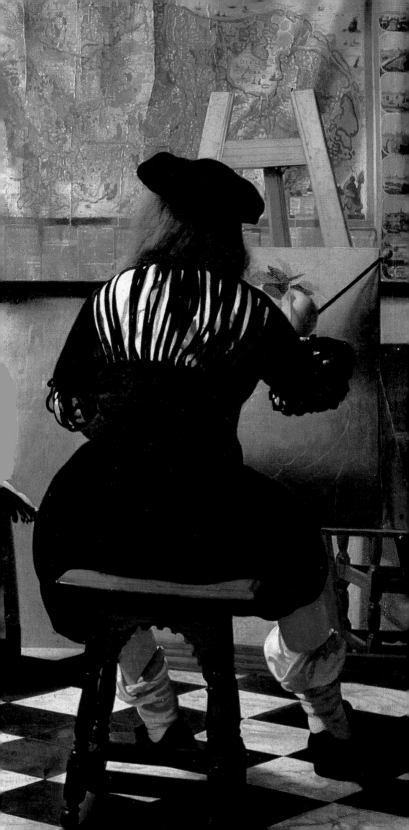

■ Accessories and Materials

While *The Art of Painting** (also known as *The Allegory of Painting*) has been considered a representation of Vermeer himself at work, the painting provides very little information concerning technique. It also shows none of the usual tools of the trade one would expect to see in a painter's studio. Scientific analyses have even revealed that Vermeer did not use the kinds of techniques that the painter in the image uses. Vermeer would first cover his painting surface with a relatively thick white layer. This layer was sometimes tinted yellow, brown or gray. After his death an inventory was taken of his studio which reveals some of the traditional materials he employed. He used an ivory-handled maulstick for difficult final touches to his paintings. He also had easels, palettes and a stone table for crushing pigments. The inventory makes no mention of his brushes. However, study of his technique and brushstrokes has revealed that Vermeer used large square-tipped brushes and smaller round pigs' hair, squirrel and otter fur brushes (Jørgen Wadum).

Although he may have sometimes used a camera* obscura to prepare his compositions and may have affixed wires to the vanishing point of his canvases to facilitate the creation of effects of perspective, the personal furniture* he employed (chairs, rugs, etc.) should also fall under the category of typical materials because, like colors and brushes, these objects were essential elements of composition. GC

■ Apprenticeship

Very little is known about Vermeer's training before his entry into the guild* in 1653. But six years of apprenticeship were required before one could enter a guild. People with whom he may have trained include Cornelis Daemen Rietwiejck, who taught painting in the Voldersgracht where Vermeer spent his childhood; Evert van Aelst, the still life painter, and Leonaert Bramer. All of these artists were close to the Vermeer family. The leading Dutch member of the *vedutisti**, Carel Fabritius, was ten years older than Vermeer and was a student of Rembrandt.* He may have introduced Vermeer to aspects of Amsterdam's artistic milieu, particularly Jacob van Loo. Archival research has indicated that Vermeer was in contact with Gerard ter Borch as early as 1653. Still, a Borchian influence is not discernible until later in Vermeer's career.

The biblical and mythological scenes Vermeer painted between 1654 and 1657 indicate stages of his development. His first paintings suggest Italian influences. See *Diana and her Companions* and *Christ** in the House of Mary and Martha,* and especially his Caravaggesque* *Procuress* (page 106–7). The influence of Caravaggio may have come via the Utrecht school, since Vermeer may also have studied with Abraham Bloemaert* in that city. GC

The Art of Painting (detail), c. 1662–65. Kunsthistorisches Museum, Vienna.

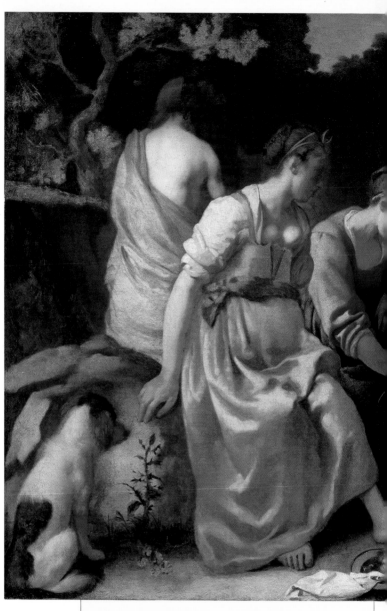

Diana and her Companions, c. 1655–56 3 ft 2 ½ × 3 ft 5 ⅜ in (1.04 m × 97.8 cm). Mauritshuis, The Hague.

■ ART MARKET
The Price of Paintings

The market for art in the northern Netherlands primarily concerned paintings and prints. Sculpture represented less than 5 percent of private holdings, and drawings were collected only by a very small number of people. Both supply and demand rose during the seventeenth century, as well as the number of master painters in local* centers of activity. Thanks to the development of the tonal, almost monochrome painting which took off in the 1630s (especially among landscape painters such as Jan van Goyen and his

followers) and still lifes (Pieter Claesz and his followers), artists were able to execute more paintings each year. The market would have been saturated and the prices would have fallen drastically if not for the reigning economic prosperity and the vogue for hanging paintings in the home. Thus prices only went down in relation to quantitative productivity, with no reduction in the income of artists—at least as far as can be told from research on the period. But earnings by renowned artists differed significantly from that of artists who painted "by the dozen" or who worked directly for dealers in popular galleries.

Purchases took place at fairs and open markets, in public buildings, and in merchants' and artists' shops. With the reduction in aristocratic and ecclesiastical commissions, artists turned to "commercial styles": landscape (see Genre Distinctions), still life* and genre* painting. Pricing was related to format and the time it took to produce a painting. Paintings representing people, especially if they were large and in the foreground, took more time to paint than landscapes and still lifes. Executed by artists of equal reputation, a portrait would thus be more expensive.

Contemporary experts strongly advocated a hierarchy of subject matter. This was probably also a significant factor, even in the cost of paintings sold more or less anonymously. Of course there was a direct relationship between an artist's reputation and the cost of paintings. A history* painting by Govaert Flinck or Rembrandt would fetch between 1,200 and 1,500 florins, and a Rembrandt portrait would sell for 500 florins. But a portrait by Bartholomeus van der Helst would sell for twice as much, due to his great popularity at the time. Landscapes by the great landscape painter Josef van Goyen would rarely bring more than 30 florins and Abraham van Beyeren's still lifes, which are tremendously appreciated today, would sell for 14 or 15 florins. Archduke Leopold William purchased one of Frans van Mieris's paintings for the huge price of 1,000 florins. Vermeer painted relatively little. John Michael Montias has estimated an output of two or three paintings a year. In 1663, a genre painting with one figure was bought for 600 florins. In 1667, after his death and during trying economic times, two paintings were sold for 617 florins. OZ

■ Art of Painting

Construction began in Delft*
on a new site for Saint Luke's
Guild* in 1661. The interior
decoration was to have the
allegories of painting, sculpture
and architecture as its sub-
jects. It is not certain whether
Vermeer participated in this
project, but the project itself
may have influenced Vermeer's
decision to work on certain
topics. While the painting now
in Vienna has often been
called *The Allegory of Paint-
ing*, it is listed in the after-
death inventory of the artist's
effects as *The Art of Painting*.
The room in the image is
probably a representation of
the room where Vermeer
painted, and the artist at work
is probably a self-portrait.*
The model poses as Clio, the
muse of history, as she is
described in Cesare Ripa's
Iconologia, which was trans-
lated into Dutch in 1644. She
is crowned with laurels and
holds a book and the "Horn
of Fame," a reminder that
history * painting is the ren-
dering of glorious deeds.
The map represents the
Netherlands, and suggests the
importance of the unity of
Dutch painting (see Local
Centers of Activity). It also
recalls the history of the coun-
try. Note that the map does
not indicate the Netherlands'
borders as they were in Ver-
meer's time, but as they were
in 1561, when the Nether-
lands belonged to the Duchy
of Burgundy.
Even though it refers to tra-
ditional artistic theories, this
painting proposes an inter-
pretation that challenges
them in its use of color* and
light* to transcribe the visual
universe. CaG

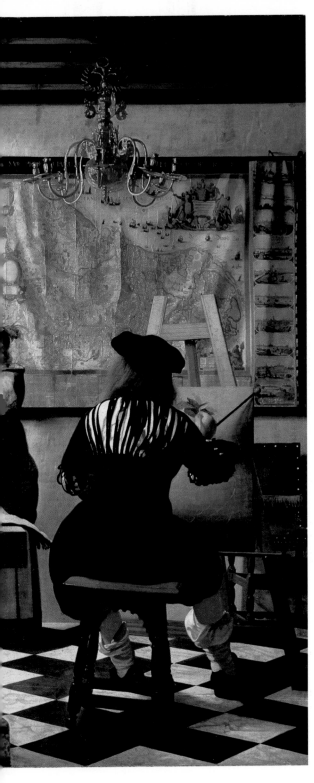

*The Art of
Painting,*
c. 1662–65.
3 ft 11¼ ×
3 ft⅜ in
(1.30 × 1.10 m).
Kunsthistorisches
Museum,
Vienna.

■ ASTRONOMER

he Astronomer has special significance within Vermeer's oeuvre. In contrast to his interior* scenes representing private life, this image relates to a tradition of representing men of science and philosophers, a sub-genre

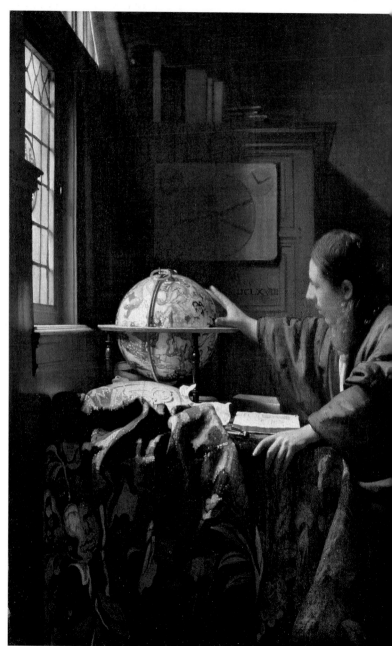

practiced by Rembrandt*: indeed, this painting has often been compared to Rembrandt's *Faust*. Still, while it does in fact relate to a scientific topic, *The Astronomer* also depicts a private space, indicating the significant place

that exact sciences were increasingly acquiring in seventeenth-century Holland. *The Geographer* (page 17) provides a perfect complement to *The Astronomer*. Between them they cover the earth and the skies, the known and the unknown parts of the universe. A complex series of correspondences link the two paintings. The room, the furniture and even the person in the image—thought by many to be Anthony van Leeuwenhoek, the great lens maker and scientist who lived in Delft—are the same. The objects echo one another: the terrestrial and celestial globes, the map* and the painting, the cupboard and the rug. But subtle differences separate them, such as the position of the objects and the figure, and the quality of the light.* The traditional attributes of astronomy are present: an astrolabe, a compass, a celestial globe, a quadrant, and a book, Metius' treatise on the movements of stars (Vermeer owned a copy of the 1621 edition). The window* and the rug assure a rectilinear distribution and division of light, which in reflecting off objects traces a kind of geometric network over the space. As in most of Vermeer's paintings, the astronomer's position indicates a specific moment in time: rising from his chair he reaches to turn the celestial globe with his right hand. The tableau on the wall, *The Finding of Moses* (see Paintings within Paintings) also provides a key to Vermeer's work. Perhaps it indicates Moses' biblical proscription of idolatry, which also concerned cults of the sun and stars. But Metius' text, which the astronomer has apparently been reading, makes allusions to the patriarchs as the first observers of the stars, and Moses, who leads the Israelites out of Egypt, is traditionally associated with travel and geography. The discovery of Moses in the river also alludes to his birth, which took place under the zodiacal sign of Libra: the traditional Libran set of scales can be discerned on the globe. CaG

The Astronomer, 1668. 19 ⅝ × 17 ¾ in (50 × 45 cm).
Musée du Louvre, Paris.

Baburen, Dirck Jaspersz. van

Dirck Jaspersz. van Baburen (c. 1595–1624) was born in Utrecht, studied painting there with Paulus Moreelse, and entered the guild* in 1611. Thus when he left for Italy about a year later, he was already a well-trained artist. He arrived shortly after Caravaggio* died, at the height of the latter's reputation. Like most of the young foreign artists of his generation in Rome, van Baburen was profoundly influenced by Caravaggio, adopting his compositional methods and his taste for plebeian characters as well as his dramatic utilization of light* and shadow. Van Baburen's reputation was quickly made in Rome, where he received numerous commissions for works in churches. His major work is the *Entombment* in the Pietà Chapel of San Pietro in Montorio, where Raphael and Sebastiano del Piombino had worked in the previous centruy.

Upon his return to Utrecht in about 1620, he became more or less the head of a school, as his paintings took on more profane subjects. He painted musicians, concerts, taverns* and brothels—such as the *Procuress Scene* (Museum of Fine Arts, Boston) which belonged to his mother-in-law Maria Thins and which Vermeer represented in his *A Lady Seated at the Virginal* (facing page) and *The Concert* (page 51). In 1622 he was one of the artists commissioned by Frederick Henry, Stadholder of the Netherlands,

Dirck van Baburen, *Procuress Scene*, 1622. 3 ft 3 ¾ × 3 ft 6 ¼ in (1.01 × 1.07 m). The Museum of Fine Arts, Boston.

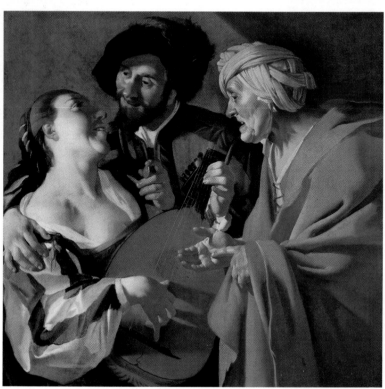

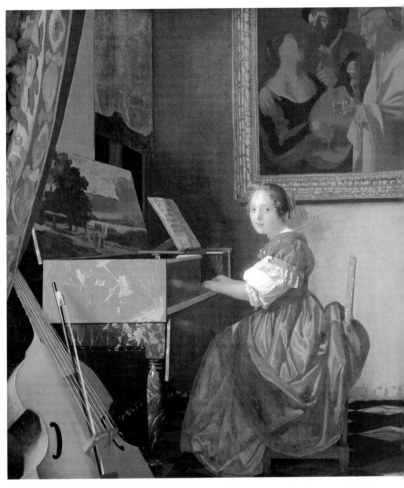

Prince of Orange, to work on a series of twelve Roman emperors. Van Baburen's contribution was *Titus*. CaG

▢ Bloemaert, Abraham

The artist Abraham Bloemaert's (1564–1651) workshop was one of the most active in Utrecht.* Having studied in Paris between 1580 and 1583, Bloemaert practiced a late mannerist style until his death. His influence on Dutch painting from the beginning of the seventeenth century is considerable and he had many students.

That Vermeer studied in Bloemaert's workshop is a tempting hypothesis, since his early works show affinities of style and subject matter with the Utrecht school. However, a stint in Amsterdam is also possible.

Bloemaert's Catholicism would not have been an obstacle to his being Vermeer's teacher, considering his excellent reputation. It may have been in Bloemaert's workshop that Vermeer began to develop Catholic convictions. This may explain his willingness to convert to

A Lady Seated at the Virginal, c. 1675. 20¼ × 17⅞ in (51.5 × 45.6 cm). National Gallery, London.

Catholicism after his engagement to Catharina Bolnes.* It is even possible that Vermeer met her through Bloemaert, since his future wife's mother had a relative and tutor who was a friend of Bloemaert's, and who also painted in and frequented the workshop. CaG

argument? Gertruyd, the artist's only sister, had married a modest frame-maker, and Vermeer's grandfather and maternal uncle had been imprisoned for counterfeiting money. The most convincing hypothesis, however, is that her hesitation was of a religious nature. Vermeer

Abraham Bloemaert, *Pastoral Scene,* 1627. 23½ × 29¼ in (60 × 74.4 cm). Niedersächsisches Landesmuseum, Hannover.

◼ Bolnes, Catharina: A Catholic Marriage

Vermeer married Catharina Bolnes on April 20, 1653. She was twenty-two years of age. Just fifteen days before the wedding, Maria Thins, the bride's mother, was willing to publish the marriage agreement, but she was still unwilling to sign the marriage contract. Thins was from an established Gouda bourgeois family. Did she hold back her signature for so long because of the disparity in social status between herself and Reynier* Vermeer, the simple artisan and innkeeper, who had even been accused of having killed a man during an

and his family were Protestants and Catharina Bolnes and her family were Catholic (see Tolerance). It may have been the intervention of Leonaert Bramer (see Apprenticeship), also a Catholic, who convinced her to accept the marriage. The Catholic ceremony took place at Schipluyden, a village near Delft* with a large Catholic population. In 1660, Vermeer, his wife and two or three children began living with his mother-in-law, in Oude Langendijk, the Catholic section of Delft, known as the Paepenhoeck (the "papist section"). He and Maria Thins were soon on quite good terms, and

Vermeer remained there until his death. The names of two of Vermeer's children, Ignatius and Franciscus, as well as one of his last paintings, *Allegory of Faith*, lead one to believe that the artist had close affinities with Delft's Jesuit milieu. GC

Borch, Gerard ter

Gerard ter Borch (1617–1681) was born in Zwolle and spent his apprenticeship in Haarlem and then in his father's workshop. After several trips to Italy, Spain and France, his career as a portraitist began in earnest; he was adept at creating dark, bare backgrounds that left lingering psychological impressions.

He and Vermeer met in Delft in 1653, on the occasion of Vermeer's wedding with Catharina Bolnes.* A contemporary notary act signed by the two artists bears witness to the fame Gerard already enjoyed compared to Vermeer. As yet there was no resemblance between their work, and it is unlikely that Gerard was Vermeer's teacher.

Around 1660, however, the resemblance between the work of the two artists became apparent, as they both took up genre* painting. Ter Borch infused his paintings with a degree of refinement that changed the genre. Very soon,

he gave up painting drinking and card-playing soldiers in favor of intimate scenes from daily life. These included *Woman at her Toilet* (The Metropolitan Museum, New York) and *Woman Writing a Letter* (above), gallant* conversations, and so on. His rooms are always illuminated with a delicate light.* Pieter de Hooch and Frans van Mieris* learned much from him, as did Vermeer. Gerard ter Borch's canvases display strong re-straint and an interesting play in the disposition of subjects, shown by his readiness to paint human figures with their backs turned to the viewer. GC

Gerard ter Borch, *Woman Writing a Letter* (detail), c. 1655. Mauritshuis, The Hague.

■ BOURGEOISIE, STRENGTH AND SYMBOLS

The Dutch Republic's strength resided in real maritime and commercial supremacy (see Netherlands), sustained by the inventive entrepreneurial success of the bourgeoisie of its larger cities. Political power was in the hands of this aristocracy of money, even if the House of Orange periodically intervened in affairs of state. The urban patriarchy provided the leaders of the cities and the representatives of the Provincial Assembly, which named the members of the General Assembly. Holland was the most densely populated, the richest, and the most influential of the provinces.

The patriarchy controlled both central and local power, while the real aristocracy, often a minority in the Assembly, only had influence in the rural provinces of Gelderland and Overijssel. This oligarchy's power was energized by a moderate, mostly tolerant, pacifist and pragmatic Calvinism.* However, conflicts were inevitable with the House of Orange and the staunch Calvinists of the middle classes.

Directed towards the high bourgeoisie and responding to its taste for simple and honest portrayals of various aspects of contemporary life—and particularly aspects of its own life—Dutch painters of the seventeenth century provided an immense quantity of small-sized thematic paintings. In this milieu, specialization by subject increased, giving rise to new genres.

Great collectors with a high level of culture, and members of the elite such as Constantijn Huygens and Jan de Witt, had their status celebrated in increasingly grand portraits. Collective portraits of militiamen of each village were executed to celebrate their roles in the war of independence. The militias were called upon in emergencies, for instance in the War of 1672,* but they mostly served to maintain order for the regents.

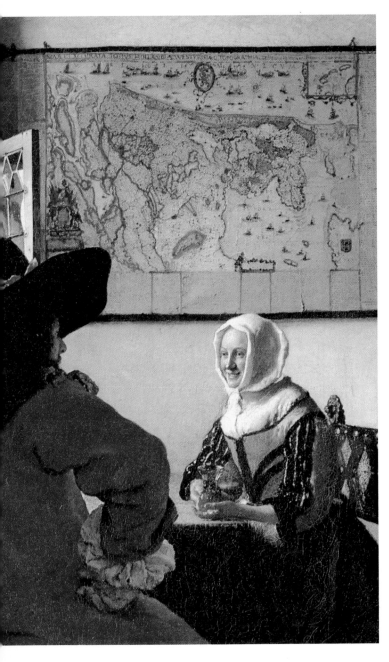

"His canvases present the art of composition employed in the subtlest way possible."

Jean-Louis Vaudoyer, 1921.

Officer and Laughing Girl, c. 1658. 19 ⅞ × 18 ⅛ in (50.5 × 46 cm). The Frick Collection, New York.

■ BUYING AND SELLING PAINTINGS
A Family Affair

On October 13, 1631, Vermeer's father Reynier was admitted into the Delft* artist's guild* as a *constvercoper,* or painting and engraving merchant. This cost him 6 florins. Membership in a local guild was necessary for conducting any business outside the confines of regulated trade grounds and fairs. Reynier probably hung paintings for sale in his inn. He was close to the painters Evert van Aelst, Pieter van Steenwijck, Balthasar van der Ast, Pieter Groenewegen, Cornelis Saftleven and Egbert van der Poel, and he probably sold their work. What is interesting is that they were still life* painters (van Aelst, van der Ast, Steenwijck), landscape painters (Groenewegen), or painters of popular scenes (Saftleven and van der Poel). In other words they painted in the genres that theorists considered inferior, but which were very popular in the middle of the century.

According to Johannes Vermeer's wife, Catharina, Johannes also took to dealing in paintings towards the end of his life. But this was during the period of economic crisis surrounding the War* of 1672 when he was having difficulty selling his own paintings. It is unlikely that these commercial transactions amounted to much (see Art Market).

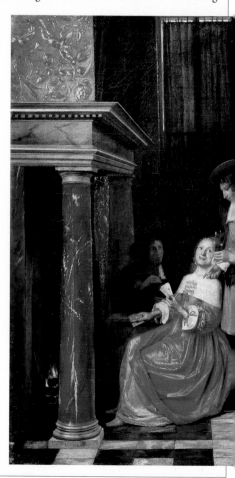

In 1663 Balthasar de Monconys visited Vermeer following his visits to Gerrit Dou,* Frans van Mieris* and Anthonie de Lorme. He wrote in his journal that "none of Vermeer's works were present." Six years later, in May 1669, the young Pieter Teding van Berckhout wrote in his journal that Vermeer had shown him "some interesting items he had made." That June, van Berckhout went again to see "that famous painter that they call Vermeer. He showed me some samples of his art of which the most extraordinary part is the perspective." This was probably a visit to the artist's studio. It is also probable that the studio was located at Maria Thins' residence at Oude Langendijk. It is also possible that Vermeer maintained a studio in his father's Mechelen Inn before it was sold in 1671. OZ

■ CALVINISM, ORTHODOXY AND DISSIDENCE
Salvation and Human Freedom

Calvinism was the official religion of the Republic of the Netherlands,* although it was not the religion of state or the only accepted religious belief. John Calvin's (1509–1564) disagreement with Martin Luther (1483–1546) centered mainly on the topic of salvation. In Luther's Augustinian perspective, sins cannot be redeemed and no one can find salvation without faith, which is a free gift from God. Calvin (see Iconoclasm) saw God's powers as even more singular, with salvation and damnation decided uniquely by predestination, not by human action. This last point was a major source of division in the Netherlands.

Starting in 1603, Jacobus Arminius (1560–1609) fought against the idea of predestination. In his conception, Christ intercedes on behalf of human beings and can be called upon to contribute to their salvation. This mitigated Calvinism was taken up by a minority of the population, including the regents and the High Governor of Holland, Jan van Oldenbarnevelt. There was some hostility between those allied to the Arminian or Remonstrant factions and orthodox Calvinists. The staunch Calvinists were called Gomarists, after the theologian Franciscus Gomarus (1563–1641).

When Oldenbarnevelt signed the Twelve Years' Truce in 1609, the bellicose House of Orange joined up with the Gomarist faction because both wanted the war with Catholic Spain to continue. Then in 1617, the Gomarist counterattack began in earnest, when Oldenbarnevelt seemed to favor the province of Holland's separation from the republic. Arminian leaders were arrested, the Synod of Dordecht condemned Arminian theses and Oldenbarnevelt was executed in 1619—the final victory of the Orangists. A number of the patriarchy of Delft were stripped of municipal office for being or for suspicion of being Arminians. Among these were Pieter van Ruijven, the father of Vermeer's great supporter. OZ

Pieter de Hooch, *An Interior Scene,* c. 1658. 29 × 25⅜ (74 × 65 cm). National Gallery, London.

■ Camera Obscura

The camera obscura (Latin for "dark chamber") is based on the principle that convergent

troversial topic. The post-mortem inventory of the artist's effects makes no men-

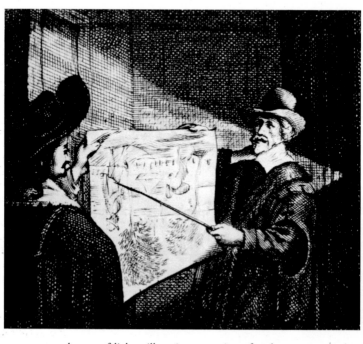

beams of light will project an image coming from their light source. The projection can be effected directly or by reflection. A darkened room with only one small hole permitting light to enter will produce the effect. The point of light projects an image that can even be focused if necessary, by placing a convex lens over the hole. Painters usually used a mobile version, a box resembling the first photographic cameras. The camera obscura allowed new possibilities for painters by revealing optical effects that are invisible to the naked eye; for example, the halo of reflection produced by a strong light on a shiny surface.

Vermeer's use of the camera obscura is a complex and con-

tion of such an apparatus (see Accessories and Materials). However, the placement of small dabs of paint in some of his works (*The Lacemaker*,* *View** *of Delft*) produce the kind of circular effects observable in camera obscuras. This technique was quite common at the time. Many painters used it as an aid to composition. However, experienced artists mainly eschewed it, considering it a good tool for younger painters and a constraint upon painterly freedom of expression.

Thus if Vermeer did use a camera obscura, he probably did not blindly reproduce its physical results, but rather "worked with its effects" (Daniel Arasse). GC

A camera obscura, engraving from Jan van Beverwijck's *Schat der Ongesontheyt*, Amsterdam, 1664. Royal Library, The Hague.

■ CARAVAGGIO, CARAVAGGISM, CARAVAGGESQUE

Caravaggio's great success in Utrecht can be explained in terms of the particularities of that city. Starting in the sixteenth century, mannerist painters were creating a favorable environment for history painting.* Some of them—such as Abraham Bloemaert* and Joachim Wtewael—continued producing into the seventeenth century.

The strong presence of Caravaggism in Utrecht is mainly due to three artists: Hendrick ter Brugghen, Gerard van Honthorst and Dirck van Baburen,* all of whom spent a good deal of time in Rome (see Italy) while the influence of Caravaggio was strong. Ter Bruggen returned to Utrecht in 1614 and the other two painters returned around 1620. They constituted a real school of painting, insofar as their work bore strong stylistic and iconographic resemblances, and it was looked to as a model by all the painters in the city. They mainly practiced genre* painting but also painted mythological and biblical scenes. They followed Italian examples in the realms of narrative organization and distribution of figures, but combined these with traditional Northern realistic facial detail, cool daylight or nocturnal, candle-illuminated scenes. Heavy shadowing and strong dark–light contrast were used to bring out particularities of an image's message. The disposition of characters and the use of costumes also attests to connections with theater, pantomime and moral satire. Vermeer's *Procuress* (page 106–7) takes its inspiration from van Baburen's painting with the same theme (page 38) which belonged to Maria Thins (see Bolnes) at the time. But the gestures and colors in Vermeer's painting are much less intense. CaG

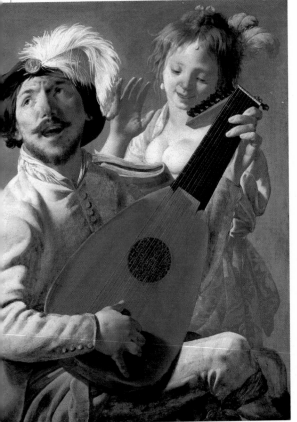

Hendrick ter Brugghen, *Duet*, 1628. 3 ft 5¾ in × 3 ft 2¼ in (1.06 m × 82 cm). Musée du Louvre, Paris.

■ CHRIST IN THE HOUSE OF MARTHA AND MARY

Like its contemporary, *Diana and her Companions*, this painting is radically different from Vermeer's later works. And like *Allegory of Faith* (page 58–9) and *St Praxedis* (page 82) whose authenticity are contested, it is a rare Vermeer work with a religious theme.

The subject comes from the Gospel of Luke and recounts Jesus' visit to the sisters Mary and Martha; while Martha is dealing with Christ, she points out the passivity of her sister who sits quietly taking in His words. Christ explains that Mary's docility is the "better part" and "it will not be taken from her" (Luke 10, 38–42).

Vermeer follows the Gospel closely. Mary sits in the foreground, upon a little stool (where the artist's signature appears). She is in a classic position of contemplation, with an elbow on her thigh and her hand against her cheek. This position tends to close the figure upon herself emphasizing the attention she is evidently paying to Christ's word. Jesus turns towards Martha while indicating Mary with his hand. Such a juxtaposition of gesture and gaze is one of the effective techniques through which history* painting dynamizes a narration while representing speech. Christ's movement is relatively common in sixteenth-century Italian painting. Albert Blankert has noted that Vermeer could have seen a similar gesture in a painting by the Flemish artist Erasmus Quellinus (1607–1678). The traditional nature of the poses suggests that the work is an "exercise." The brushstrokes are large and strong, very different from the fine style of Vermeer's maturity (see Dou), and closer to the Caravaggesque* school of Utrecht. The space is constructed schematically, with the the effects of depth achieved largely through the volume of the figures and color.* The rug on the left corner of the table prefigures Vermeer's future work. GC

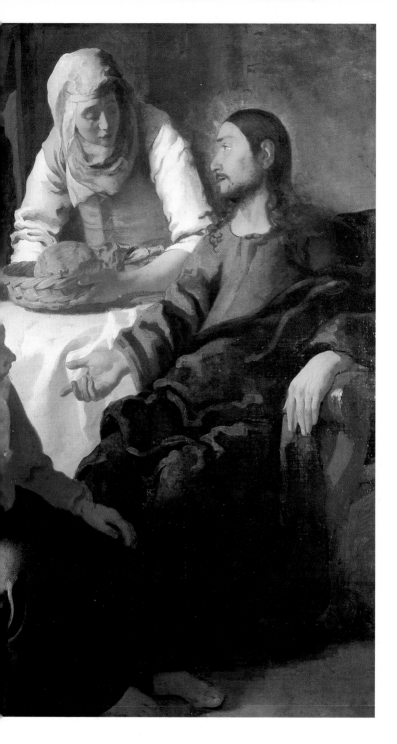

Christ in the House of Martha and Mary, c. 1655.
5 ft 3 in × 4 ft 8 in (1.60 × 1.42 m). National Gallery of Scotland, Edinburgh.

■ COLOR
Vermeer "illuminates the entire canvas" (E. J. T. Thoré-Bürger)

Color, like light,* is an essential aspect of Vermeer's technique. It is important in defining form as well as composition. The harmony of colors is in fact a result of Vermeer's precise handling of light and his exacting control of its amplitude. Color is first of all a range. A large percentage of the chromatic prism appears in Vermeer's work, with blues and yellows dominating. Red is used for brightness and warmth; neutral tones in the background bring out the play of reverberations among colors. His favorite pigment is a lapis lazuli-based ultramarine—which contrasts so well with ochre and yellow. This blue serves as the base of all Vermeer's shadowing. Mixed with brown, it gives an equivalent of black, a color which Vermeer banished from his paintings. By the same token, green is obtained by mixing the blue with a vegetable yellow. But the color has turned with age, and Vermeer's greens have oxidized, turning blue. (*Woman in Blue Reading a Letter,* page 78).

The Lacemaker (detail), c. 1669–70. Musée du Louvre, Paris.

Color density is a function of light. Contrast zones are defined by applying larger patches of intense colors, most often with smaller patches of less intense hues nearby. Pointillism is also a coloring technique which is often related to the use of the camera* obscura and the optical phenomena it creates. For instance, it reveals an increased texture to objects with increased light. When Vermeer dabs little drops of pure color on the surface of things, the play of light upon material becomes more perceptible. CaG

■ Curiosity Cabinets

Curiosity cabinets or *Wunderkammern* began to appear in the sixteenth century as a kind of descendant of medieval treasury collections. The sixteenth-century versions presented many sorts of objects, including sculpture, gold and silver objects, scientific instruments and specimens from the natural world. All these items were gathered together for contemplation as the physical manifestations of the humanist Renaissance desire to understand all

manner of things and to master all realms of knowledge. A number of painters in seventeenth-century Antwerp specialized in scenes of visits to curiosity cabinets.

These curiosity cabinets, also called *Kunstkammern,* were almost palatial affairs, with halls covered with rows and rows of paintings. The com-bined predilection for painting and study can be seen in Vermeer's *Geographer, Astronomer, Concert* (below) and *A Lady Standing at a Virginal* (page 94–5), but in an attenuated and more intimate form. Vermeer also enjoyed reproducing paintings by members of his own family on the walls in his paintings. OZ

The Concert, c. 1664. 28 ½ × 25 ½ in (72.5 × 64.7 cm). Isabella Stewart Gardner Museum, Boston.

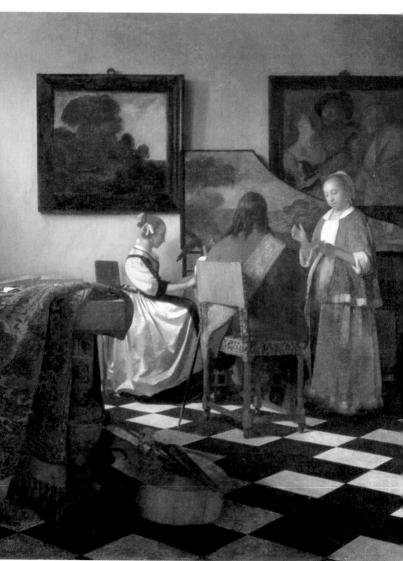

■ Death and Memento Mori

Dutch still lifes are often called *vanitas*. The name derives from illustrates the same idea. The skull is a fundamental vehicle in this sort of contemplation. It symbolizes the transitoriness of

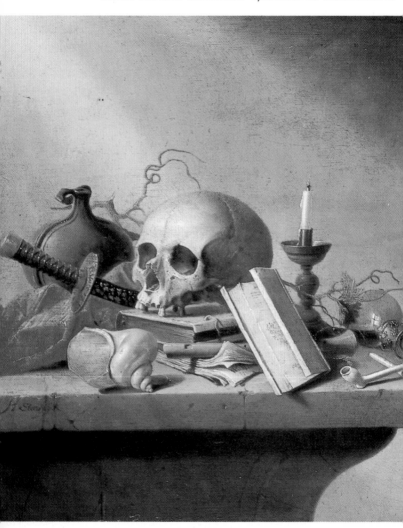

Harmen van Steenwijck, (1612– after1656) *Still life.* 12 ft 4½ in × 12 ft 5½ in (3.77 × 3.82 m). Stedelijkmuseum, Leiden.

Ecclesiastes, "vanity of vanities, all is vanity," and the form developed into an emblematic system whose purpose was to remind people of the brevity of terrestrial life and the importance of contemplating one's end. Vermeer's *Woman Holding a Balance,* (page 114–15)

human existence better than any other object, suggesting the vanity and decay of the flesh and the eventual return to dust of physical human remains. Butterflies and dragonflies symbolize life after death, the recompense for a virtuous life. Flies and earwigs are reminders

of original sin, and the shortness of life in general.

Paradoxically the message of *memento mori* seems to be "enjoy the pleasures of life while you can." Don't all these u n d e n i a b l y symbolic objects refer back to the reality of Dutch society, its increasing wealth, and its partiality to comfort and luxury? Even if the artist took pleasure in rendering these objects, and the spectator shares in this pleasure, their symbolic value remains: candles burn down; clocks mark the passage of time; flowers fade; fruit becomes worm-eaten. All creatures have a common destiny. Mirrors reveal the vanity of appearances. And paintings reveal all as illusion. CaG

■ Delft
A City and
Its Painters

It may be assumed that in a nation such as the Dutch Republic, where painters traveled a great deal, describing their particular attachment to one city would be difficult. One means of fixing an artist to a particular place, however, is provided by discovering which city's guild* contains his name in their rolls. The right to practice one's art and sell one's work was granted by the guild. Enrolling in a particular place also indicates a relationship to the artistic community there.

Important painters worked in Delft from the beginning of the seventeenth century. These included the successful portraitist Michiel van Mierevelt and the elegant genre painter of merry outdoor company scenes Anthonie Palamedesz. Corstiaen Couwenbergh and, in some of his portrait work, Willem van Vliet, belonged to the Utrecht school's Caravaggian* current, and Jacob Pynas's biblical scenes belong to a line descending from Rembrandt's* Amsterdam predecessors. In 1628, Leonaert Bramer* returned to Delft after ten years in Italy. He made his reputation with biblical and mythological history* paintings, and did *al fresco* works, usually as official commissions. The rise in Delft's importance as an artistic city dates to the 1630s. Balthasar van der Ast, who was trained in Middleburg and Utrecht, established himself there in 1632. He and Jacob Vosmaer were the preeminent painters of flowers and fruit. Gerard Houckgeest was one of the first painters of church interiors in 1635, and one of the originators of the illusionistic current. Hendrick van Vliet and Emmanuel de Witte would soon excel at this; their tableaux unite a perfect mastery of perspective with a real sense of pictorial space.

The rustic school was important at the same time. Egbert van der Poel (whose father married Reynier Vermeer's sister-in-law) was probably an

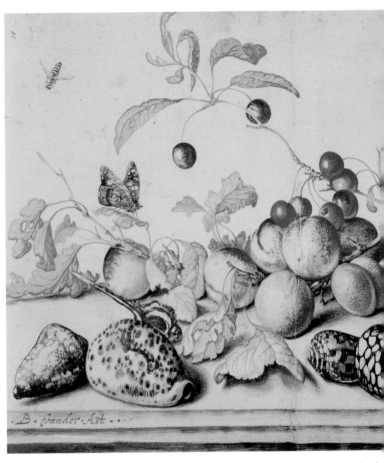

Balthazar van
der Ast,
(before 1590–
after 1656)
*Still Life with
Plums, Cherries
and Seashells.*
Watercolor.
British
Museum,
London.

early influence on Pieter de Hooch.* Carel Fabritius (see Vedutisti) gave the Delft school decisive momentum between 1651 and 1654. He was the strongest influence in Delft due to his ability to confer monumentality to small-sized works and by his very free adaptation of Rembrandt's chiaroscuro techniques onto paintings composed with a bright, light-filled palette.

The success of private interior genre* painting dates to approximately 1655. Its most notable practitioners are de Hooch in Delft and Nicolaes Maes in Dordecht. Traces of their influ-

ence can be seen in the work of the young Vermeer. In parallel, the 1650s also saw the spread of 'fine' painting. Gerrit Dou* and Johannes Torrentius were its initiators. It is said that these artists painted so finely that their canvases leave no trace of brushwork. Dou's main student, the precocious Frans van Mieris, was an early influence on Vermeer. While Delft possessed a lively and productive artistic community around 1650, the city went into decline after 1660. The important painters left in search of more active cities, such as Amsterdam and The Hague. CaG

> **"To our great sorrow [Carel Fabritius] left this life at the height of his fame. But it is to our great happiness that Vermeer has been born from his ashes to perpetuate the master's genius."**
>
> Cited from Dirck van Bleyswicjk,
> *Beschryvinge der stadt Delft*,
> Amsterdam: Arnold Bon, 1667.

Diana and her Companions (detail), c. 1655–56. Mauritshuis, The Hague.

■ Dogs

As domestic animals *par excellence*, dogs were indispensable accessories in scenes of interiors* and private life, and were thus omnipresent in Dutch painting. They are found in tavern* scenes, they serve as witnesses to gallant* conversations and they accompany reading female figures. While a dog may serve to counterbalance the potential for infidelity that comes with a letter* or with a glass of wine,* other canvases use dogs to suggest bawdiness.

Dogs are often found in the paintings of Pieter de Hooch*

and Gerard ter Borch. Nevertheless there is not a single dog in Vermeer's interior or rare exterior scenes—which would seem suitable places to find one. The only dog and in fact the only animal in any of Vermeer's paintings is found in *Diana and her Companions* (page 32–3), an early work dating to 1655–56. In his near complete exclusion of canines, as with the near exclusion of children in his iconography,* Vermeer's work indicates how much the subject matter of "realistic painting" of early modern* life was a matter of choice. GC

Dou and the Leiden 'Fine' Painters

Gerrit or Gerard Dou (1613-1675) was the head of the Leiden school, characterised by meticulous attention to detail. Leiden is located between Delft and Amsterdam. Fine painters, or *fijnschilder,* such as Dou and his students Frans von Mieris and Gabriel Metsu, specialized in genre* painting. Their subject

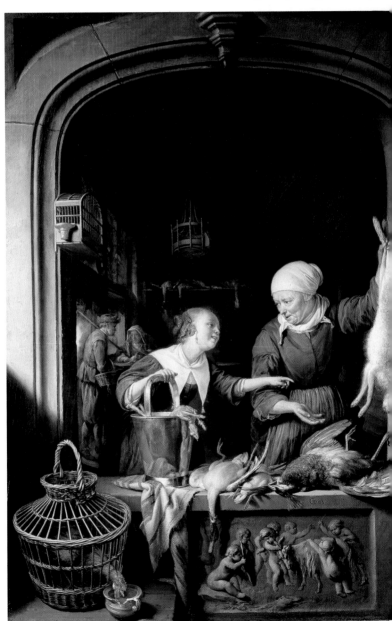

matter resembled that produced in other local* centers of activity in the Netherlands—women engaged in everyday tasks or playing music, and so on. But their paintings are distinguished by such glossy surfaces that this effect becomes the real subject of their work. After Rembrandt* left for Amsterdam in 1632, Dou began developing an exacting style. His representations of minute detail solicit close inspection by the viewer. A contemporary of the artist said that Dou's paintings made him feel like bringing a lamp right up to the image in order to count the stitches on a bedroom curtain.

The Leiden high bourgeoisie appreciated such paintings and was more than willing to pay high prices for them (see Art Market). They agreed with the paintings' manifest rejection of historical and mythological themes. *Fijnschilders* painted on wood only and the preciousness of their production required them to work slowly. They used only the finest silk brushes which enabled them to reproduce precise details. Dou was the most meticulous of these painters. He was so careful that before getting to work, he would wait several minutes after arriving in his studio so that any ambient dust would settle. Having learned chiaroscuro techniques from Rembrandt, he applied them regularly in his portraits. Another characteristic of his work is the almost systematic employment of the motif of the niche. GC

Gerrit Dou, *Venison Shop*, c. 1650. 22⅝ × 18¼ in (58 × 46 cm). National Gallery, London.

■ EUROPEAN PAINTING TRENDS
Baroque, Classical, Caravaggesque

Other artistic movements were developing throughout Europe at the same time as seventeenth-century Dutch painting. In Italy, the Counter-Reform led painters such as Pietro da Cortona and Giovanni Gaulli to elaborate a triumphal art that would later come to be called the baroque. The great sculptor and architect Gianlorenzo Bernini, the central figure in this current, was Vermeer's contemporary.

Flemish artists were particularly interested in the evolution of Italian painting and its baroque aspects. Rubens (1577–1640) along with his Antwerp students, Jacob Jordaens and Frans Snyders, developed a painting style rich in movement and color that would find some echoes in Holland, notably with Rembrandt in the 1630s.

After 1660, French art was following the example of Nicolas Poussin and painters from Bologna, such as Carrachi and Guido Reni. The French artists Eustache Le Sueur, Philippe de Champaigne, Charles Le Brun and others broke with the colored lyricism of Simon Vouet.

The best way to understand how Dutch painting related to that produced elsewhere in Europe is to consider the influence of Caravaggio* in the Utrecht school. GC

■ FAITH

Religious subjects are rare in Vermeer's oeuvre, and date for the most part to his early output. *Christ in the House of Martha and Mary* (page 48–9) and *St Praxedis* (page 82) were probably destined for Catholic patrons. The latter image of the female saint was most probably painted for a private Jesuit patron. Its size makes a church an unlikely destination.

Catholics were granted a certain level of religious* tolerance after 1579, but were not in fact permitted to practice their religion freely. The organized prayers of members of the older branch of Christianity took place in "underground churches," simple rooms in secular buildings. *Allegory of Faith* seems to represent one of these improvised places of worship. It depicts a room with a black and white tiled floor, soberly decorated and lit by a small-paned window that is reflected in the suspended glass bowl. The image in the background (Jacob Jordaens' *Crucifixion,* which belonged to Maria Thins) and the liturgical objects on the makeshift altar, evoke the religious character of the place.

Vermeer borrowed most of the components of the *Allegory*, his last known work, from Cesare Ripa's *Iconographia,* which he probably read in Dirck Pietersz Pers' Dutch translation of 1644. But Vermeer interprets Ripa's text with a great deal of artistic license. The female figure dressed in contemporary costume represents the triumph of Faith over heresy, represented by the snake beneath her left foot. Her right foot rests on a globe of the earth, proclaiming the universality of Catholic doctrine. These last were popular symbols during the Counter-Reformation. For this reason, some consider *Allegory of Faith* to be a politically charged work. The presence of allegorical elements such as the female figure of faith, the globe, the cornerstone crushing the snake, and the suspended glass vessel, might be surprising elements to find in a Dutch painting of the time, building because they go against classical imperatives of coherent representation. This combination of realistic and allegorical components bears witness to the artist's ambition to participate in the contemporary history of painting, while elaborating a novel theoretical stance.

Vermeer's introduction of new modes of representation within the traditional allegorical genre effects a modification of the traditional way of understanding both allegory and genre* painting. CaG

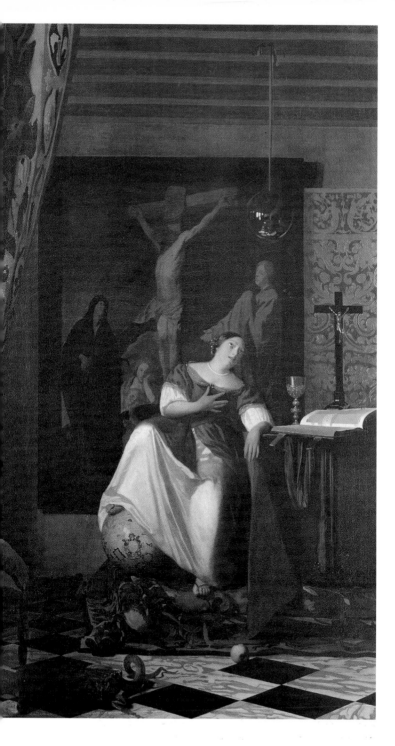

Allegory of Faith, c. 1671–74. 3 ft 9 in × 35 in (1.14 m × 88.9 cm).
The Metropolitan Museum of Art, New York.

■ Forgeries

The nineteenth century regeneration of Vermeer's reputation (see Reputation) led to the production of numerous works that were strongly influenced by the master. This infatuation reached an extreme form in the work of Hans van Meegeren. Counterfeits made by this very particular Dutch painter were identified at the end of the Second World War after it was discovered that van Meegeren had sold a tableau signed Vermeer to the Nazi leader Hermann Goering. When tried for financial collaboration with the Nazis, van Meegeren revealed that he had been introducing fakes into the market for years, and that some of these were in the world's most important museums. This skilled counterfeiter had a more or less scientific method of proceeding. He would take the works of lesser seventeenth-century masters, remove the paint, and repaint them. He even contrived paint brushes from bristles of badger hair shaving brushes that tricked the experts. Vermeer criticism has never been the same since van Meegeren. Art historians had accepted a number of biblical scenes as Vermeer's, thinking them to be works made during Vermeer's apprenticeship.* Historians became extremely wary after the hoax was revealed, and the number of works attributed to Vermeer was reduced considerably (see Lost, Found, and Discarded Paintings). There is also a small number of specialists who go so far as to accuse van Meegeren of lying; in their view the works are Vermeer's, and van Meegeren is merely claiming that he could paint as well as the master. GC

Young Woman with a Water Jug, c. 1664–65. 18 × 16 in (45.7 × 40.6 cm). The Metropolitan Museum of Art, New York.

■ Furniture
Vermeer's Object Repertory

There are only a small number of specific objects represented in Vermeer's oeuvre, although those that appear do so fre-

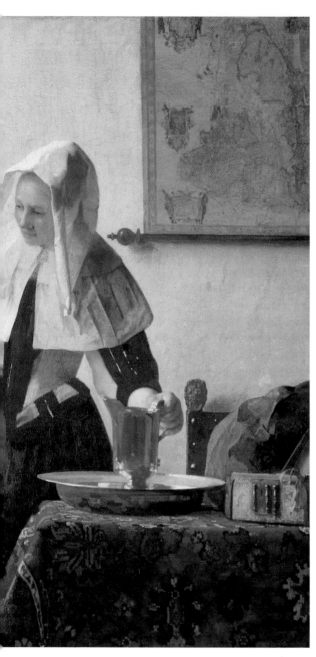

quently. They are meticulously
painted, and their recurrence,
albeit sometimes with slight
variations, suggests that they
were part of his own day to
day décor. In fact he owned
some of the paintings* within

paintings found in his oeuvre.
Vermeer's repertory includes
maps, the globe in *The Geogra-
pher* (page 17) and *Allegory of
Faith**, and the *Astronomer*'s*
book which is so clearly ren-
dered that James Welu was

able to identify the precise edition used. Maria Thins' will (see Bolnes) mentions a gilt silver wine jug, an object so unusual that we can probably identify it in *Young Woman with a Water Jug* (page 60–1). The inventory made after Vermeer's death describes other accessories* and materials that are consistently seen in his paintings, such as chairs with lion-head ornaments, and an ivory box (*A Lady Writing*, page 21), an ivory crucifix (*Allegory of Faith*), and an ivory handled stick (the maulstick in *The Art* of Painting*). The virginals were probably executed after the example of an instrument owned by Maria Thins. Rugs are another type of fur-

nishing in Vermeer's painting vocabulary. The patterns are similar from painting to painting, but Vermeer modified certain aspects such as color* and size according to his compositional requirements. GC

■ Gallant Conversation

During the 1650s, genre* painting evolved from representing brothels and taverns,* with their large gestures and overt sexual content, to more discreet and less sexually blatant "gallant conversation." Representations of relationships between men and women came to be manifested in the form of intimate dialogues taking place in private quarters. This genre was soon adopted by Vermeer.

He changed his focus from a scene where a man tenaciously puts his arm around a woman (*The Procuress*, page 106) to scenes where the two figures are separated, presenting a lighter suggestion of sexual attraction (*Officer and Laughing Girl*, page 43; *The Glass of Wine*, left). The subject matter of these *tête à tête* is suggested by the protagonists' gestures and looks, but also by certain details that reveal the degree of the couple's intimacy: the glass of wine* the soldier offers the woman in *The Girl with Two Men* (page 112–13), music,* the subject matter of the paintings* within paintings (such as maritime themes which symbolize love lost at sea and the search for a calm port).

The women in Vermeer's paintings are very much occupied with writing and receiving letters,* which are another means of gallant conversation, even if these take place across a greater physical distance. GC

The Glass of Wine, c. 1660–61. 25⅝ × 30¼ in (65 × 77 cm). Gemäldegalerie, Berlin-Dahlem.

■ GENERATION OF 1650

In the middle of the seventeenth century, a number of younger artists, most of whom were specialists in history* painting, (Jacob van Loo, Gabriel Metsu), began to take an active interest in genre* painting, thereby shaking up the conventions that had been established around Amsterdam and Haarlem in the 1630s.

In Delft, painters such as Carel Fabritius (see Vedutisti) and Nicolaes Maes, both students of Rembrandt, worked on creating effects of light and perspective that led to more refined treatment of genre scenes. Vermeer learned much from the work on perspective in interior scenes introduced by Pieter de Hooch. Gerard ter Borch,* the other great innovator of the genre, invented and innovated upon some of the themes which came to be Vermeer's favorites, such as a woman writing a letter.* With Borch, interior scenes became less expansive, there were fewer human figures, and the subject matter itself became more refined. Around 1650, paintings of brothels and peasants playing cards in taverns* disappeared from the repertoire of genre painting. Intimacy became the essential element (see Interiors and Gallant Conversations) and was invested with a moral value that was revealed in details such as paintings* within paintings. Dutch genre painting thus achieved a true level of "respectability" at this time. GC

■ GENRE DISTINCTIONS
The Dutch Exception

In painting, genre distinctions are based on subject matter as much as style. This is why art historians such as Carel van Mander, Philip Angel and Samuel van Hoogstraten differentiate between the noble genre of history* painting and "inferior" genres, such as landscape and still life.* Portraits and genre* painting, that present refined personages are located between the two. But these categories are not inflexible. A degree of idealization or grandeur of style can augment a painting's status.

Distinctions also exist within each genre. These result in part from artists' particularities and specializations. City and coastal views became divisions of landscape painting; animals, flowers and fruit, seashells, table tops, banquets and allegorical *vanitas* (see Death) became divisions of the still life.

While the concept of genres dates to antiquity, today's distinctions date from the Renaissance. New categories of painting appeared and artists came to establish themselves in relation to these specific types. In Holland, specialization was directly related to conditions of the art* market. Choice of subject matter was a response first of all to general demand rather than to particular patrons. Paintings were often real pre-industrial products; artists created finished objects, with different versions varying only slightly.

Jacob van Ruisdael (1628–1682, *The Bush.* 26¾ × 32¼ in (68 × 82 cm). Musée du Louvre, Paris.

Facing page: Jan Steen, (1629–1679) *Tavern Revel,* 3 ft 10 in × 5 ft 3½ in (1.17 × 1.61 m). Musée du Louvre, Paris.

Economics thus propelled painting. This was the case for portraiture, launched by people's desire to leave an image for posterity, and genre painting, whose subject matter could be understood by a broad public. Portraits were an important source of income for artists, functioning at the same time as an advertisement for their work. Still, the relationship was conflictual: presenting a likeness of the sitter meant submitting to the defects of nature—this demand was opposed to the idealization of subject matter which the epoch required of serious artistic creation. CaG

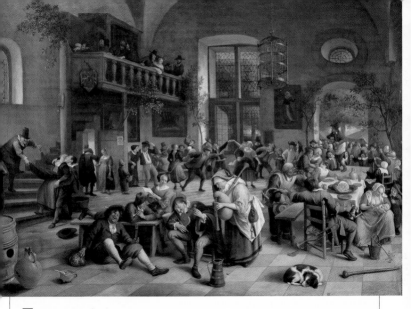

■ GENRE PAINTING

The term "genre" first came to be applied to paintings representing everyday life in the eighteenth century, to distinguish them from history* painting and its more noble subject matter. As Jacob Cats has pointed out, genre painting finds its subject matter in the repertory of emblematic literature, putting innocuous figures into realistic frameworks.

The beginnings of genre painting date to the sixteenth century. It originated in the southern Netherlands and then began to concentrate in the north between 1610 and 1620. The works of Essaias van der Velde and Willem Buytewech did much to bring about its acceptance as an important form. In addition, the Flemish artist Adriaen Brouwer's stay in Haarlem (1628–31) did much to influence Adriaen van Ostade's style and subject matter, particularly in the treatment of grotesque and satirical subjects, which became his specialty. In Leiden, where the influence of Gerrit Dou* predominated, the genre displayed different characteristics, namely the fine and meticulous attention to detail, bright color*—and with more complex subject matter, a response to the interest of a university-town clientele.

In Utrecht, genre painting was more closely related to history painting in both size and pictorial treatment. This was part of its attachment to Caravaggian* approaches. In Delft,* Pieter de Hooch* and Vermeer were most interested in representing calmer interior* scenes, whose effects were often related to the use of clear or softly filtered light.

The nature of genre painting's subject matter led artists to invent new modes of representation. It was an innovation for the narrative content of a tableau to be created without textual reference. Subject matter remained important, but its proverbial illustrations or moral lessons were based on less erudite sources. This was the basis of its success with its audience, the dominant bourgeois class. However, Dou's, Jan Steen's and Gabriel Metsu's paintings are in effect metaphorical because they transform "fragments of reality" into symbolic moralizing content. Thus none of their work is innocent or purely anecdotal. Whether representing taverns* or brothels, dinner scenes, the interior of inns or bourgeois homes, all this work can be reduced to a single perspective on life and fate. Moral constancy is the hidden message toward which the images of dissipation and worldly pleasures and the total absence of the potential of eternal heavenly reward point (see Generation of 1650). CaG

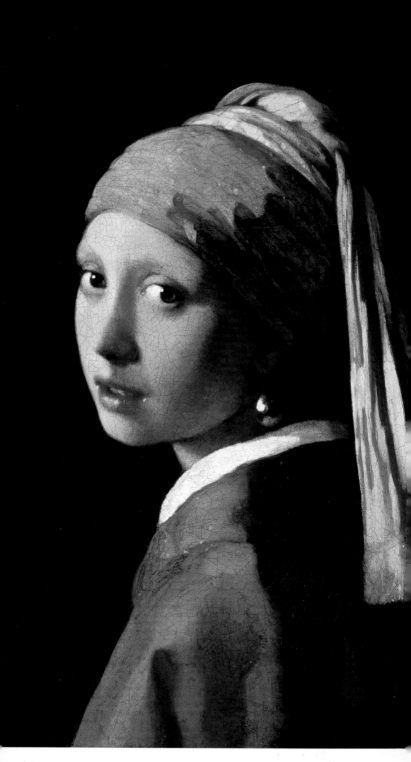

■ Girl with the Pearl Earring

Only two head and shoulder portraits by Vermeer survive, this one in the Mauritshuis (The Hague) and *Head (or Portrait) of a Young Woman* in the Metropolitan Museum, New York. Controversy concerning authenticity still surrounds two other head and shoulder portraits (*Girl with a Flute* and *Girl with a Red Hat*, both at the National Gallery, Washington DC), and *Mistress and Maid* (The Frick Collection, page 103), a work in which the background is bare. *The Girl with the Pearl Earring* is wearing a Turkish style turban, one of several examples of oriental accoutrements found in Vermeer's work (the painting is known in some other languages as *Young Woman with a Turban*). Her head comes forward in masterful contrast against the black background, which constitutes the entire extent of the painting's décor. The painting radiates an amazingly "natural" effect, partially created by the position of the figure who is turning as if to look over her shoulder at the spectator. The reflection in her eyes, the image of the window* in the pearl, and the tiny gleams on her lower lip contribute to giving this face an intense sense of present vitality. According to Albert Blankert, the origin of this pose can be found in a painting by Frans van Mieris.*

Yet Vermeer radicalizes the technique of making a monochrome background in order to avoid creating an effect of depth; he offers no clear cut delimitation between the different surfaces and parts of the face. The background and the figure interpenetrate each other. The girl's features are defined with color* and light* only. For example the bridge of the nose is not clearly drawn. The nose effectively melts into the right cheek (Blankert) and there are no defining contour lines in the portrait. This technique resembles Leonardo da Vinci's *sfumato,* the rendering of depth by chiaroscuro rather than precise lines. Da Vinci's Mona Lisa is also known as *La Giaconda,* and another name for this painting is the *Giaconda of the North.* GC

■ Guilds and Academies

The development of groups of craftsmen into guilds began in the Middle Ages. In this system, associations of painters and sculptors were considered on the same level as people working in other trades.

In the sixteenth century, artists benefited from important social status and sought to dissociate themselves from other sorts of artisans. This led to the creation of the first academies in Italy,* a model that was adopted in other European countries over the course of the seventeenth century. But in Holland, except for a perfunctory undertaking in Utrecht in the 1590s, the academic model was eschewed at least during the seventeenth

The Girl with the Pearl Earring, c. 1665–66. 18¼ × 15¾ in (46.5 × 39 cm). Mauritshuis, The Hague.

Crispijn de Passe the Younger, *True-life Drawing of the Utrecht academy.* Engraving from *La Luce del dipingere,* 1643, Amsterdam.

Gérard de Lairesse, (1641–1711) *Cleopatra's Arrival in Tarsus.* 23½ × 26½ in (60 × 67 cm). Musée du Louvre, Paris.

century. Excluding occasions where they formed other sorts of associations (Dordecht 1642, Utrecht 1644 [see Caravaggism], Leiden 1652, The Hague 1655), painters remained attached to guilds. This movement had little impact in Delft, where painters continued to rub elbows with members of other guilds, such as weavers, engravers, sculptors, porcelain* glaziers, printers and binders. Delft and Haarlem had the most conservative artist's guilds in the Netherlands.

Upon its fiftieth anniversary in 1661, Delft's Guild of Saint Luke changed its headquarters, but reaffirmed its commitment to its 1611 charter and artisanal traditions. In principle the status of the guilds in every city was the same. They were directed by their syndics, or headmen, who were named by the membership and confirmed by municipal authorities. Artists were required to have completed an apprenticeship* period of four to six years before they could be admitted into a guild as a master. Most guilds required painters to submit a "masterpiece" for acceptance by the syndics. Glassmakers, porcelain makers and apprentices of less noble crafts were subject to the same procedure. Artists and artisans could not practice without having received formal recognition. CaG

■ Hidden Symbolism

This notion derives from Erwin Panofsky (1892–1968), the great art historian and the "inventor of iconology." He used the terms "hidden" and "disguised "symbolism in work he had done on Italian painting and applied it to early Netherlandish style. He sought to describe the real meaning behind the seemingly innocuous realistic representations of certain details and ordinary objects in the work of Flemish Primitives.

This kind of analysis has subsequently been applied to seventeenth-century Dutch painters, and particularly to Vermeer. Thus, for example, the apparently simple representation of objects and the real world in *The Art* of Painting is understood as an allegory of the arts. As mentioned, Panofsky's method was originally developed for Italian painting. When applied to Dutch painting, it proves to be somewhat reductive. The problem is the difference between using the theory to interpret works with strongly descriptive (Dutch) as opposed to those displaying imitative (Italian) thrusts and traditions. GC

■ HISTORY PAINTING
After Raphael

Seventeenth-century Dutch painting cannot be reduced to a series of realistic portrayals of everyday life. Any account of Dutch art must also consider history painting as well as connections to Italian theories and practices of painting. History painters in Holland lost their traditional patrons in the first two decades of the seventeenth century: Catholic churches were destroyed or given over to Protestant worship, and the aristocracy's role in society diminished. Still, educated people continued to appreciate and to purchase such works. Another cause of history painting's decline was the aesthetic dominance of realistic representation. Practical-minded, Calvinist Holland tended to mistrust pure products of imagination, because of their distance from factual and tangible reality. In addition, history painting's traditional capacity for moral and spiritual edification could be satisfied by the works of genre* painting, landscapes

(see Genre Distinctions) and still lifes.* History painters came to be subject to the influence of realistic trends. This appeared most of all in efforts to give works compositional coherence based as much as possible upon the texts from which their subject matter was taken. For example, the Utrecht school renewed the genre with a more monumental and dramatic approach and interesting use of light and shadow, lessons they learned from Caravaggio.* At the end of the century the influence of French classicism was evident, particularly in the work of Gérard de Lairesse (see European Painting).CaG

69

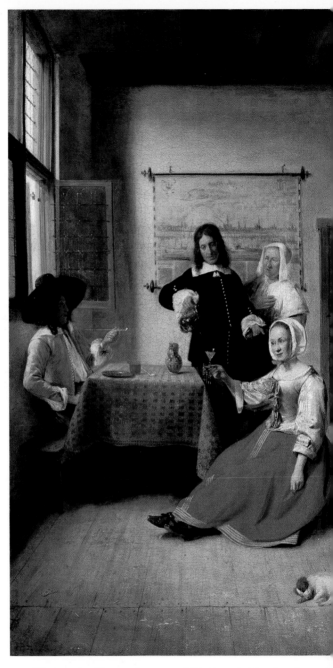

■ **Hooch, Pieter de**

Pieter de Hooch (1629–1684) was three years older than Vermeer. He was originally from Haarlem and moved to Delft in 1653, enrolling in Saint Luke's Guild two years later.

This is probably when he and Vermeer met. Vermeer's discovery of Hooch's work was a crucial moment in his painting career, for Vermeer's painting took a decisive turn in the late 1650s.

defined spaces, with ceiling beams and floor tiles defining precise perspectival space (*An Interior Scene,* left).

Starting in approximately 1660, Vermeer changed how he painted, abandoned history painting and adopted some lessons he learned from de Hooch (*Officer and Laughing Girl,* page 42–3). He simplified his process by reducing the number of figures and using more diffuse light (*The Milkmaid,** and *Woman with a Pearl Necklace,* page 96). De Hooch in turn picked up a few things from Vermeer. For example, he reproduces almost all the detail of *Woman Holding a Balance* (page 114–15). De Hooch also repeated his own compositions, sometimes enlarging details and making them into independent works. GC

Pieter de Hooch, *An Interior Scene,* c. 1658. 29 × 25 ⅜ in (74 × 65 cm). National Gallery, London.

■ Iconoclasm

The Iconoclastic Revolt of 1566 was a decisive moment in the conflict between Catholics (see Religious Tolerance) and Protestants before the Netherlands'* twenty-seven provinces broke from Spanish control. Its immediate effects were the destruction or mutilation of religious works in more than 400 churches and the hardening of the Spanish position, which included dispatching the troops of the Duke of Alba. Acting against the repression of the Spanish inquisition, Calvinist extremists had attacked what they considered manifestations of papist idolatry; Protestants reject both representations of God, the Holy Spirit and the divine incarnation of Christ, because these cannot be described by human means, and iconoclastic worship via the image of saints.

De Hooch reinvigorated genre* painting with his original portraiture techniques and his mastery of perspective. His figures are bathed in light that diffuses in from large windows, and they are placed in rigorously

After the signing of the Union of Utrecht in 1579, Calvinism became the quasi-official religion of the new state of united provinces, and paintings and sculpture were removed from the churches.

Calvinist pastors forbade the representation of Christ and the Virgin in public places and private homes as well. On the other hand they tolerated and even encouraged the representation of biblical scenes, landscapes and still lifes. Painters such as Jan Victors, an ultra-Calvinist, avoided subjects deriving from the New Testament, and only represented elements from the Old Testament.

Pre-Rembrandt Catholic painters, such as Leonaert Bramer, Pieter Lastman, and Jan and Jacob Pynas followed this Protestant example. Rembrandt* however, who belonged to the Reform community, painted the Virgin with Child, angels and even the face of Christ. In Haarlem the Catholic painters Pieter de Grebber and Jan de Bray tended to produce allegories and devotional works, a genre that was strongly condemned by the Calvinists. With his *Allegory of Faith*,* Vermeer belonged to this current. He was probably influenced by the Jesuit milieu of his wife and mother-in-law. OZ

Nach wenigh Predication
Die Caluinsche Religion

Das bildens sturmen fiengen an
Das nicht ein bilde dauon bleib stan
Anno Dni. M. D. LXVI. XX Augusti

Kay Monsfrantz, kelch, auch die oltar
Vnd weiß sonst dort vor handen war.

■ ICONOGRAPHY

The quality of Vermeer's oeuvre does not reside in his choice of subject matter (for instance the works were often commissions). It relates to the innumerable variations he put to traditional iconographic elements. Throughout his career, Vermeer paid close attention to evolving trends and adopted their themes. In his apprenticeship* years he painted mythological scenes (*Diana and her Companions,* page 32–3), and history* paintings. He then took on genre* painting and interior* scenes, representing figures in gallant* conversation, reading or writing letters,* or playing music.* He also elegantly painted popular subjects, such as people drinking or engaged in domestic activities *(The Lacemaker*, The Milkmaid*)*.

On the other hand, he avoided common themes, such as outdoor scenes, painting only two (*The Little Street,* page 80–1 and *View of Delft,* page 110–11). A third painting, now lost, is mentioned in the inventory. Vermeer's originality comes from the treatment he gives to this classic repertory: very precise and regular framing of the image, systematic repetition of the same location, meticulous elaboration of intimate private spaces, and above all an unresolvable play of symbolism (see Hidden Symbolism) that always provides several interpretative possibilities for the viewer (see Paintings within Paintings). GC

Franz Hogenberg, *Iconoclasts: the destruction of church relics and statues after Calvin's preaching, August 1566.* Engraving from the Geneva Public and University Library.

n all in kurtzer ſtundt
r viel leuten das iſt kundt .

■ Interiors and Privacy

Vermeer is a painter of private interior space, as his entire oeuvre amply shows (see Iconography). He might even be considered the painter of a single interior, since the same elements of décor appear in almost all his works.

Vermeer never represents a room in its entirety. He shows it from a particular angle. Only three paintings portray both the ceiling and the floor, *The Art of Painting* (page 34–5), *Allegory of Faith* (page 58–9) and *The Music Lesson* (page 89). Vermeer's interiors have a regular pattern. Light* diffuses from the wall on the left, and another wall serves as the backdrop for the interior dramatic play. The latter wall is sometimes bare, but is often decorated with maps* or other paintings (see Paintings within Paintings). The floors in these interiors are tiled in black and white (or green and yellow: *The Glass of Wine,* page 62–3),

*Girl Reading a
Letter at an
Open Window,*
c. 1659.
32¾ × 25⅜ in
(83 × 64.5 cm).
Gemäldegalerie,
Dresden.

giving the rooms a high degree of bourgeois elegance. Vermeer only paints private homes, never public places, like brothels and taverns.*

The regularity of these scenes suggests that he represented a space he was familiar with, and that he painted rooms from his own home. These interiors also furnish the opportunity of revealing people's private lives, and evoking their emotional state. Vermeer places individual figures in his rooms, creating a sort of voyeuristic view of their movements (*Woman in Blue Reading a Letter,* page 78). But the subjects' intimacy is also protected by the clearly delineated space. The foreground is filled with chairs, curtains or tables which act to protect the protagonist's privacy. As opposed to Pieter de Hooch,* Vermeer never places a door or window in the background: there is never a specified outside for the gaze to move to or an opening out from the private space. Vermeer paints "intimacy in the heart of privacy" (Daniel Arrasse). GC

■ Italy
The Southern Temptation

The "Voyage to Italy" was an important aspect of an artist's formation in the sixteenth and seventeenth centuries. Italy was considered the country of the arts. It possessed both the principal works of ancient and modern times, and it was the place where new ideas developed and artistic perspectives were constantly being rejuvenated. It was also an economically stable region which therefore provided opportunities for artists. Many artists of the Burgundian Low Countries and then the Netherlands* made

their way there. Some stayed for life, such as Paul Bril and Pieter van Laer. Others, like several landscape painters and the Utrecht Caravaggians,* remained for long periods. Among Delft artists, these include the history and still life painter Leonaert Bramer (see Apprenticeship) and the landscape painter Pieter Groenewegen. Dutch painters were most attracted to Rome. But they did not just blend into the Roman world and the international artistic community; they gathered together into a group called the Bentvueghels. Their reform religion also distinguished them from most of the other artists.

Italian influence upon the art of other countries is well known. But sometimes influence went in the other direction, most notably in landscape painting (see Genre Distinctions). While Italy provided painters with new motifs (steep mountainous terrain, ruins, etc.,) the artists of the Dutch Republic exported their specialties, the use of draftsmanship in exteriors and attention to variations in light.* They also brought a taste for nocturnal scenes illumined by artificial light. Joachim von Sandrart, the author of a celebrated treatise on painting, attributed the invention of the new candlelight genre (that Claude Lorrain would soon make famous) to them. CaG

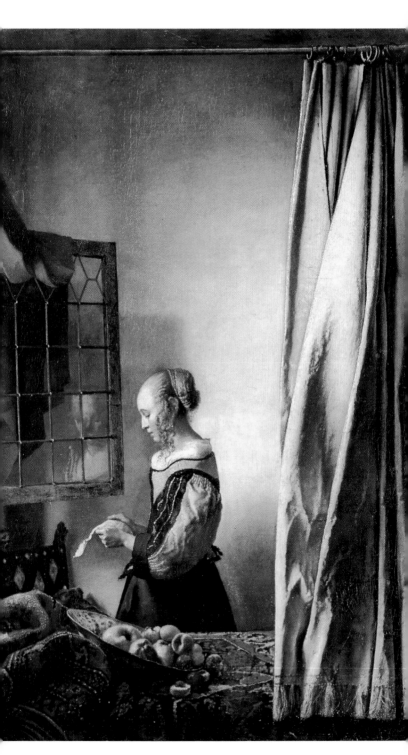

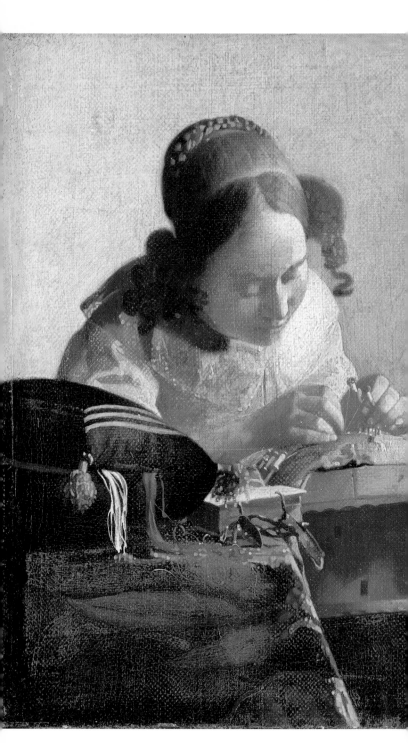

The Lacemaker is Vermeer's smallest painting. Its format immediately creates a sense of intimacy with the viewer who must come up close to contemplate it. As a work from the latter part of Vermeer's career, it provides evidence concerning the processes that led Vermeer increasingly to represent female figures, while progressively decreasing the number of figures he would put in each work. It is also a strong example of his tendency to focus on an isolated figure. The tight framing of the image and the situating of the vanishing point and the spectator's perspective at a low angle, confer a monumentality upon the woman at work. Although the image is particularly emotionally engaging, the intensity is also made more distant by the interposition of the objects in the foreground which interrupt the view of the subject. Both the angled view and the position of her right hand make it impossible to see what she is working on.

Unlike most of Vermeer's paintings, the light* comes from the right. Its effect on objects and the use of color* create an imperceptible veil, which alleviates the compact neatness of the composition. The world appears to be out of focus. Form is not defined by draftsmanship or line, but by color. The artist's supreme interest in the suffusion of light upon bodies, and the decomposition of color that this creates, render traditional and geometrical explanations of form inappropriate.

Possible recourse to the camera* obscura or other optical instruments may partially explain the unfocused rendering and the idiosyncrasies of depth of field. The red and white threads in the foreground are treated as simple colored marks and trails of color, and small dabs of color are used to transcribe the play of light upon textured surfaces. That they appear in places like the rug and cushion where they could not have appeared in a camera obscura is technically interesting and inventive. In the relationship between painting and the science of optics, the latter always plays a secondary role in Vermeer's work. CaG

The Lacemaker, c. 1669–70. 9 ⅝ × 8 ¼ (23.9 × 20.5 cm).
Musée du Louvre, Paris.

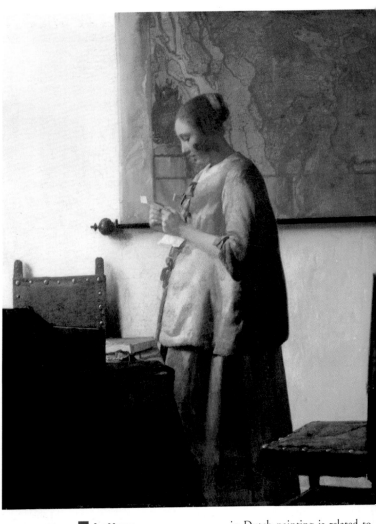

Woman in Blue Reading a Letter, c. 1663–64. 18¼ × 15¾ in (46.6 × 39.1 cm). Rijksmuseum, Amsterdam.

■ Letters

Letters and epistolary motifs are the primary topic of Vermeer's iconography.* Like most painters who specialized in the genre (see Borch and Metsu), Vermeer systematically represented every aspect of the epistolary exchange, from the writing of the letter (*A Lady Writing,* page 21) to its reception (*The Love Letter,* page 18–9) to its being read (*Woman in Blue Reading a Letter,* top). The importance given to letter writing in Dutch painting is related to the country's having the highest level of education in Europe.

As a means of conveying lovers' discourse letters serve complex functions for Vermeer. While men are often absent from the images in this genre, their (erotically charged) presence is maintained through the letter. The emotional state of the woman in her solitary concentrated reading cannot be pinned down precisely, but it serves to reinforce the intimacy of the

interior.* A servant* may be the only figure to accompany the reading. According to art historian Svetlana Alpers, letters were a favored motif for painters because they mirror the relationship of the "art lover's" attention to the work's details. And finally, as the great fifteenth-century theorist of art Leon Battista Alberti described the work of art itself, letters miraculously render what is absent present. GC

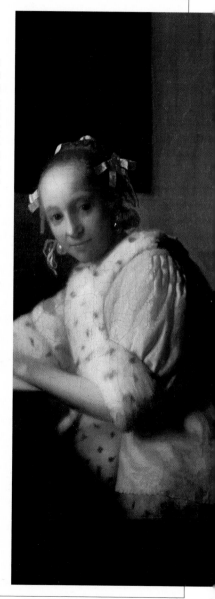

A Lady Writing (detail), c. 1665. National Gallery of Art, Washington, DC.

■ LIGHT
"There is no black"
E. J. T. Thoré-Bürger

The light in Vermeer's paintings can be considered as a continuation of the bright range of color in Paulus Potter's and Adam Pijnacker's work and Pieter Saenredam's employment of light to structure spatial configuration. But Vermeer's main inspiration was Carel Fabritius (see Vedutisti), who took much of his inspiration from Rembrandt in the utilization of chiaroscuro as a compositional technique.

In his exterior views, *The Little Street* (page 80) and *View of Delft* (page 110–111) Vermeer makes use of contrast in light and intensity of color to achieve realistic effects. In his interior* scenes, he opts for a softer, more diffuse light and a careful modulation of chiaroscuro that creates subtle transitions between bright and dark tones.

Space in Vermeer's paintings is constructed, and is a product of, light. The reverberations of light among objects comprise the geometry of the painting as much as the lines of composition. Wall hangings and rugs (like window* shutters, which are never presented directly, but which sometimes appear in reflections) assure the distribution and range of light.

Vermeer also uses light to reveal form, which effectively contributes to the idealization of what is represented. Paradoxically, in Vermeer's paintings "drawing" exists not as lines but through the treatment of light; the discontinuity of light creates contour. Drawing is replaced by the application of juxtaposed colors* which render the luminous impression. CaG

■ THE LITTLE STREET

When Vermeer painted *The Little Street* c.1657–1658, city scenes were still a fairly new genre. Pieter de Hooch was one of the first to paint such views. His contemporary series of urban landscapes (see Genre Distinctions) might well have inspired Vermeer. It was formerly thought that the building in Vermeer's painting represented either Saint Luke's Guild or the old people's homes on the Voldersgracht, but there is no evidence for either theory; nor it is known whether this house was related to the artist's life in any way.

The composition is similar to Vermeer's interior* scenes, in which a close-up point of view delimits the space, accentuates verticality, and blocks access to the background. The walls and windows* provide no sense of interior volumes. This is reinforced by the work's stringent geometrical structure: the straight lines are underscored by the bricks, the window casings, and the leading and glass panes which create a regular surface rhythm. Light follows suit: the bright colors and exact modeling are achieved with the famous stippling technique.

The spatial closure expresses the closed system of the representation. The figures are absorbed in their activities and unaware of the viewer's presence. There is no relation between the figures in the image. They are arrayed in an inverse triangle, facing in opposing directions. The children—rare in Vermeer's work—turn their back to us; their activity remains a mystery, inscribed in the imaginary, incomprehensible space of play. This ambivalence translates to a formal ambiguity in the composition: the face and arms of the woman in the doorway are articulated with a few strokes of color, and the kneeling girl's skirt seems to meld with the pavement. CaG

The Little Street, c. 1657–58. 21 ⅜ × 17 ⅜ in (53.5 cm × 43.5 cm). Rijksmuseum, Amsterdam.

St Praxedis,
1655.
3 ft 4 in ×
32 ¾ in
101.6 ×
82.6 cm.
The Barbara
Piasecka
Johnson
Collection
Foundation,
Princeton.

■ Local Centers of Activity

The existence of artistic foyers correlates with the presence of artists within economically productive localities, as well as with the existence of guilds* through which they would practice their artistic trade. The characteristics of the foyers in each city were closely related to local cultural traditions and the ways in which younger artists appropriated these and oriented themselves in relation to them. The multiplicity of centers should not obscure the fact that there was a high degree of coherence within Dutch painting as a whole. The painters of Amsterdam, Haarlem, Leiden (see Dou) and Utrecht most definitely communicated with one another. Leaving aside the divisions that may have existed within each school, the principal characteristics of all were tendencies to realistic representation, minute description, bright colors and effects of light.*

The geography of the country made movement from place to place an easy matter, and this contributed to the artists' ideological and technical unity. Dutch cities are quite close to one another, and an efficient system of transportation by canal and river existed. In addition to each city's particular activities, there were many venues for artistic exchange. Artists' travel itineraries are well documented and include several motivations. People traveled to begin apprenticeship* in cities with strong artistic reputations. Popular destinations were Utrecht and particularly Amsterdam, where Rembrandt reigned as the principal master. They also traveled back to their city of origin, and they set themselves up in cities where economic conditions seemed favorable. CaG

■ Lost, Found, and Discarded Paintings

Vermeer's output was slim. He only painted about twenty other paintings besides those known today. Among these were an *Entombment* (the three Marys) a *Jupiter, Venus and Mercury* (along with *Diana and her Companions,* page 32–3, one of Vermeer's two mythological

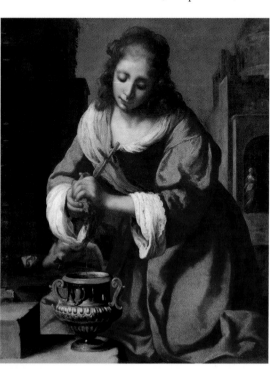

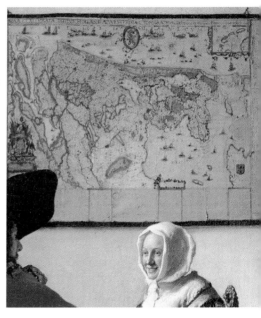

subjects), a *Man and Woman Playing Music*, a *Woman at her Dressing Table*, a *Head of a Girl* (probably along the lines of *The Girl with the Pearl Earring** or the *Portrait of a Young Woman* (Metropolitan Museum of Art, New York), and a *View of a Delft Home*. A curious *Portrait of Vermeer with Accessories* is mentioned in seventeenth-century references. To this list may be added copies in Vermeer's style and counterfeits from throughout the centuries. The authenticity of *St. Praxedis*, a copy of a painting by the Florentine artist Felice Ficherelli, signed Vermeer, is a subject of debate among specialists. The attribution of two Washington DC portraits, *Girl with a Flute* (page 22) and *Girl with a Red Hat* (page 23), is also sometimes contested (John Michael Montias). Despite a host of typical Vermeer details, *Girl with a Red Hat* displays several suspicious features: the figure's odd positioning in relation to the chair and the chair's lion head ornaments turned in opposite directions. This painting and *Girl with a Flute* are the only Vermeer works executed on wood as opposed to canvas. GC

▪ Maps and National Pride

The accomplishments of Gerhardus Piscator (1519–1594) led to advances in map-making as well as increased diffusion of atlases. Thanks to Jodocus Hondius and the Blaeu family, Amsterdam was a European map-printing capital. The Dutch middle class became quite fond of them, and hung maps of their country, Europe and the Indies on the walls of their homes. These maps served to satisfy intellectual-historical curiosity as well as patriotic enthusiasm—by affirming and perpetuating the geographical and political existence of the young nation and the extent of its commercial and maritime influence.

Officer and Laughing Girl (above, The Frick Collection, New York) may be suggesting the military backing behind such national pride. The map represents Holland and West Friesland, the heartland of the United Provinces in the war against Spain.

The map was drawn by Balthasar Floris van Berckenrode in 1620 and published many times by William Jansz Blaeu (1571–1638) between 1621 and 1629. Land is colored blue and water brown, with the north to the right. Vermeer has five maps in his works, reflecting contemporary Dutch interior* decoration, but also, perhaps, a means of asserting the status of both Dutch painting and cartography. OZ

Officer and Laughing Girl (detail), c. 1658. The Frick Collection, New York.

The Glass of Wine (detail), c. 1660–61. Gemäldegalerie, Berlin-Dahlem.

■ Materiality versus Perception

The way that Vermeer represents objects differs greatly from his contemporaries. His intense attention to defining objects is not accompanied by

"Vermeer is an amazingly original master. One might say that his Milkmaid is the ideal that Chardin was after: there's the same milky paint texture, the same tiny checkerboard of color melting into solidity, the same buttery rippling and the same curdled thickening of the incidental objects."

Edmond and Jules Goncourt, *Journal,* 1861.

minute description. Vermeer is a realist painter who has little interest in realistically representing things. In Vermeer's universe, the quality and quantity of light* on surfaces provide more texture than the rendering of materiality. Certainly, different kinds of objects are treated differently. In order to represent their weight and opacity, rugs and tapestries are often painted with small juxtaposed and superimposed touches of the brush. Glass and metal are defined with bright, thin strokes of color.*

Vermeer's figures have often been described as seeming to be in suspended animation. The stopping point of their movements is as important to him as making his subjects seem to be in the process of appearing, captured between the materiality of the canvas and the immateriality of time and existence.

The impression of evanescence that these paintings evoke results from dematerializing the represented world in the image. Vermeer presents the visible and perceptible world rather than the tangible reality of material objects. Thus the "reality" that Vermeer refers to is representation and the limits of the visible: the real domains of art. CaG

■ Metsu, Gabriel

Metsu's (1629–1667) work evolved along similar lines to Vermeer's. Beginning with history* painting, it developed towards genre* painting, and examples of religious painting are rare. Metsu was born in Leiden and probably did his apprenticeship with Dou,* from whom he must have learned the techniques of 'fine' painting.

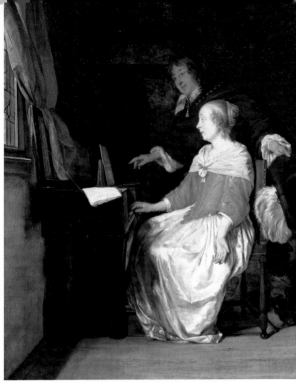

When he arrived in Amsterdam in 1657 his reputation as a genre painter was soon quite strong. After 1660 the influence of ter Borch* and Vermeer is apparent in his utilization of a small number of figures in interior scenes, playing music* or writing letters.* However, Metsu's canvases remain anecdotal, developing a range of simple and familiar emotions that are not found in Vermeer's iconography.* Among other things, he painted tender themes like *The Sick Child* (1662, Rijksmuseum, Amsterdam) and popular scenes, such as people at the market. GC

among students." Van Mieris had numerous clients in various countries of Europe, and from the early 1660s his works easily earned him at least 300 florins a piece. But he spent his fortune very quickly and had dissolute habits. He died at the age of forty-six.

■ Mieris, Frans van

The work of Frans van Mieris (1635–1681) was quite important in Vermeer's elaboration of his own style. When van Mieris arrived in Leiden he almost immediately entered Gerrit Dou's* workshop, where he was considered the "prince

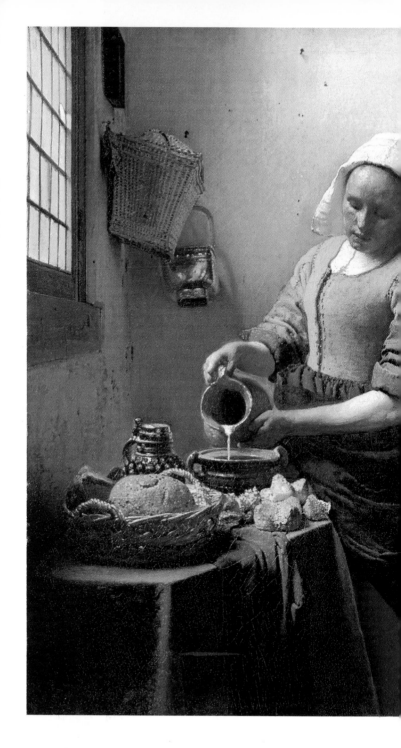

The Milkmaid, 1658–60. 17⅞ × 16⅛ in (45.5 × 40.6 cm).
Rijksmuseum, Amsterdam.

■ MILKMAID

This work certainly marks Vermeer's perfection of lessons learned from Nicolaes Maes and Pieter de Hooch.* The harmonious image presents an isolated figure absorbed in domestic activity, surrounded by objects that constitute a range of details, whose presence captivates the eye and engages it with the canvas. Pieces of bread, pitchers and jugs, a plate, a suspended plate-warmer and a foot-warmer on the ground all surround this domestic servant.* The room is plain, with blank walls, a bare window and undecorated porcelain* tiles.

Unlike the rest of the painting's iconography,* a woman pouring milk is not an invention of Vermeer's or a Vermeerian theme. It is found in the kitchen scene sub-genre, the most accomplished examples of which are by the Antwerp-born artist Pieter Aertsen. *The Milkmaid* is a modernized and refined version of the kitchen scene. It is possible that Vermeer was inspired by one of Gerrit Dou's paintings in which a woman looks out at the spectator while pouring water into a receptacle (Musée du Louvre, Paris). But Vermeer's special touch is seen in the way this woman's lowered eyes create a feeling of intimacy.

X-rays reveal that Vermeer treated the table's still life and the milkmaid differently. The woman is composed in a first layer of paint whose spirited brush strokes suggest a single posed session with a live model. X-rays also show that Vermeer had initially painted a map* on the wall. The final state presents only a blank wall (but marked with nails, indicating the position of a former hanging of some kind) that allows light* once again to become the real subject of Vermeer's work. This canvas's pointilla stippling, particularly on the handles of the bread basket, suggests that Vermeer may have used a camera* obscura for the compostion. GC

■ Modern Painting and Contemporary Life

Seventeenth-century Holland is known for its genre* painting. But it would be inaccurate to consider genre painting as the only pictorial mode appreciated at the time. True, the middle classes greatly enjoyed seeing reflections of themselves in these canvases. But genre painting also drew its energy from the aesthetic hierarchy that existed during Vermeer's career. For instance, genre painters were always conscious of classical imperatives. Gérard de Lairesse (1640–1711) was the most active practitioner of the classical style, and he made sure that those around him knew of its exigencies. And it was understood that the most noble occupation that a contemporary painter could have was history* painting. Theorists and artists of the time who believed that painting had intellectual functions thought genre painting lacked precise rules and even a practical basis upon which such rules could be established. The "modern" also runs the risk of being a prisoner to its contemporeneity: in the opinion of some, its representations of changing conditions and styles dooms it to last as long as the subjects it represents. GC

■ Music and Musicians

Musical instruments occupy an important place in Vermeer's oeuvre. They may sit quietly like the guitar in *The Glass of Wine*, (page 62–3) or the bass viol in *A Lady Seated at the Virginal* (page 39), or they may be primarily subjects in a scene, like the lute in *The Love Letter* and the virginals in *The Music Lesson* (facing) and *A Lady Seated at the Virginal* (page 39), the harpsichord in *The Concert* (page 51) or the guitar in *The Guitar Player* (Iveagh Bequest, Kenwood House, London). Portrayal of musical instruments belongs to the traditions of genre* painting, where the representation of concerts provided occasion for depicting gallant* conversation. Like Frans van Mieris'* *Duet*, Vermeer's *Music Lesson* shows how more comes into play than the notes alone in this sort of encounter between men and women. Music was often associated with wine in genre* painting, and both were used to establish "harmony" between protagonists. In *The Music Lesson* the young man's position as a prisoner of his love for the young woman is amplified by virtue of the image on the wall behind him. Lawrence Gowing has discussed the fact that the partially visible painting *Roman Charity*, depicts a daughter offering her breast to her famished, imprisoned father. Vermeer has also placed a painting of Cupid holding a playing card in

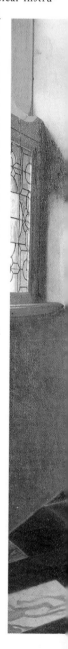

the background of *A Lady Standing at the Virginal* (page 94–5). But Vermeer was also a real music lover. It is known that Vermeer's father played some kind of flute, and he probably transmitted his passion for music to his son. Vermeer played music with friends and attended concerts. He is holding a zither in what is thought to be his self-portrait.* GC

The Music Lesson, c. 1662–64. Buckingham Palace, London.

■ Netherlands
The Republic and Maritime Power

The Republic of the Netherlands was created following a series of revolts between 1566 and 1572 in what was formerly the Burgundian Low Countries, then under Spanish control. Spain's increasing centralization and the intensity of the Inquisition led to unrest (see Iconoclasm) followed by a long war that devastated the southern territories. The Twelve Year Truce between 1609 and 1621 provided temporary interruption of the destruction that then continued until 1648. In 1579, seven Calvinist northern provinces (the United Provinces) claimed independence as the Union of Utrecht. The Treaty of Munster, signed during the Peace of Westphalia in 1648, recognized their independence, while what is now Belgium remained subject to Catholic Spain, as Spanish Flanders.

This long conflict between a small nation and the great Spanish monarchical power, and the central role of Calvinists in the struggle, contributed to creating a particular form of Dutch patriotism. It was based on the belief that their nation was chosen by God to be saved from oppression because it had chosen the true faith. Like the Israelites of the bible, they had a special connection with God. The fleets of three provinces, Holland, Friesland and Zeland, maintained the military and commercial dominance of the United Provinces in Europe—at least between 1640 and 1680. The Dutch East India Company and the Dutch West India Company monopolized trade in Asia and the Americas, taking over routes and commercial domains from Portugal and Spain. England suffered as well. Holland also maintained a banking system that was well advanced for its day, through which it benefited in the area

Ludolf Backhuyzen (1631–1708), *The Port at Amsterdam Seen from IJmuiden.* 4 ft 2½ in × 7 ft 3 in (1.28 × 2.21 m). Musée du Louvre, Paris.

Jan Davidsz de Heem, *Prince William III*, c. 1670. 4 ft 4 ¾ in × 3 ft 9 in (1.34 × 1.14 m). Musée des Beaux-Arts, Lyon.

of international commerce. The Calvinist work ethic also played its part. By authorizing the lending of funds it also contributed greatly to the development of capitalism. It also contributed to the development of democracy and cultural values. As a republic surrounded by European monarchies, the Netherlands also cultivated a higher level of freedom of expression. This led to progress in the sciences (Anthony van Leeuwenhoek, Constantijn and Christiaan Huygens) and the development of philosophical thought (Spinoza and Descartes who published all of his works there.) OZ

Orange, the House of

The Dutch Republic's Stad-holders were members of the House of Orange Nassau, the hereditary Princedom of Orange (in France) and the Netherlands. They served as the heads of the armed forces, counterbalancing the civil powers of the Regents and the Pensionary.

The federation of Dutch Provinces had their own monetary and legislative systems and religious authorities, but it lacked a centralizing political authority. In the seventeenth century the Stadholders often assumed this function, due to their important role in the war of independence; take the patriotic bearing of the mausoleum of William the Taciturn (1533–1584) in Delft's* New Church. The House of Orange was aggressive. At times it joined forces with staunch Calvinist factions, and it strongly promoted the annexation of Spanish Flanders.

Knowing how to exploit divisiveness, the House of Orange threw its patriotic weight into conflicts concerning the Holland Pensionary, whose power and interest were mercantile. Twice their discord lead to the death of the Grand Pensionary. Jan van Oldenbarn-evelt (b.1547) was executed in 1619. He had been an architect of the peace of 1609 and had supported the independence of Holland. In 1672 Jan de Witt (b.1625) was killed by a crowd that was aroused by the Stadholder William III's efforts to save the country from the French. OZ

Paintings within Paintings

When seventeenth-century Dutch painters represent a domestic interior*, they almost always place a painting on one of the walls within the representation. After paintings were proscribed from Protestant Reformed churches, their presence in private homes multiplied (see Curiosity Cabinets), and came to symbolize and represent this private space itself.

The themes of the paintings Vermeer places within his works are good reflections of contemporary taste, and the difference between contemporary taste and his own. There are a number of religious landscapes (*The Finding of Moses,* twice), a *Cupid*, a history* painting (*Roman Charity*), a portrait and a still life.* These paintings probably belonged to Vermeer or his family and were thus part of the décor of his day to day life.

We know for example that his mother-in-law owned *Procuress Scene* (page 38) by the Utrecht Caravaggian* Dirck van Baburen. An image of this painting can be seen in Vermeer's *Concert* (page 51) and *A Lady Seated at the Virginal* (page 39). The *Crucifixion* by the Antwerp artist Jacob Jordaens can be seen in *Allegory of Faith**. These paintings within paintings are not simple anecdotal details, they provide moral indexes for the scenes. Still, their symbolic meaning often remains uncertain in Vermeer's work as he also uses them compositionally. This is why the format of *The Finding of Moses* differs in *Lady Writing a Letter with her Maid* (page 24–5) and *The Astronomer* (page 36–7). QC

Following pages: *A Lady Standing at the Virginal,* c. 1672–73. 20¼ × 17⅞ in (51.8 × 45.2 cm). National Gallery, London.

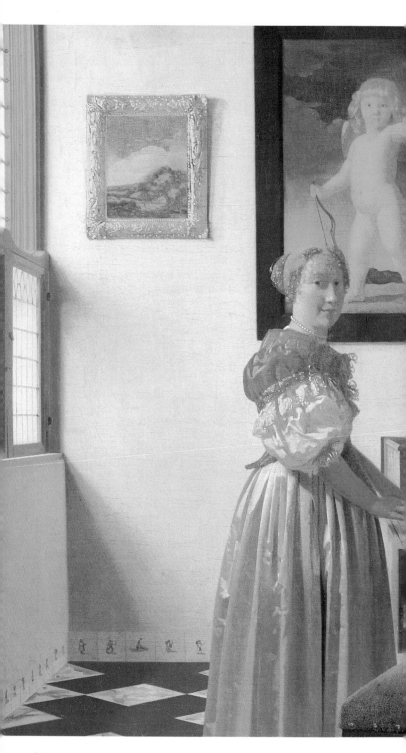

■ PATRONS AND COMMERCE
Vermeer's Protectors

Prosperous countries with particularly rich artistic traditions also usually produced wealthy patrons who made it possible for artists to protect themselves from the commercial vicissitudes of the art* market. Through its commissions, the House of Orange* supported Flemish as well as Dutch history painters* (Gonzales Coques, Gerard van Honthorst, Jacob Jordaens). In his youth, Rembrandt benefited from Constantijn Huygens' commissions; Huygens was an important figure at the Orange court.

Pieter Spiering Silvercroon, The Hague's "resident" (ambassador) at the Swedish court was a patron of the genre painter Gerrit Dou,* and Frans van Mieris had Cosimo de' Medici and Archduke Leopold V of Austria as patrons. While other collectors (Vredenburg, Isaac Michielsz, Gerard and François de le Boe Sylvius) are known to have sold works of his which they owned, some painters set up contracts for future works with established dealers. Thus collector and patron were not always distinct categories.

Vermeer had at least one patron, Pieter Claesz van Ruijven, a close relative of Pieter Spiering, Frans van Mieris' patron. Van Ruijven loaned Vermeer money early in his career, left him 500 florins in his will of 1665 and purchased one or two of his paintings each year. In the end he owned twenty, among which were *The Milkmaid** and *View* of Delft* which he bequeathed to his daughter, Magdalena Pieters.

When Magdalena Pieters died in 1682 the Van Ruijven collection went to her husband, Jacob Dissius. In 1696, a year after Dissius' death, the collection was sold in Amsterdam. That was in 1696. The baker and money lender Hendrick van Buyten (visited by Balthasar de Monconys in 1663) was also interested in Vermeer's works. He purchased one painting from Vermeer during his lifetime and acquired two more from his widow in lieu of a debt of 617 florins accumulated over the years from the purchase of bread. The 'fine' painting practiced by Dou, van Mieris and Vermeer required so much time to execute that patrons were extremely important. OZ

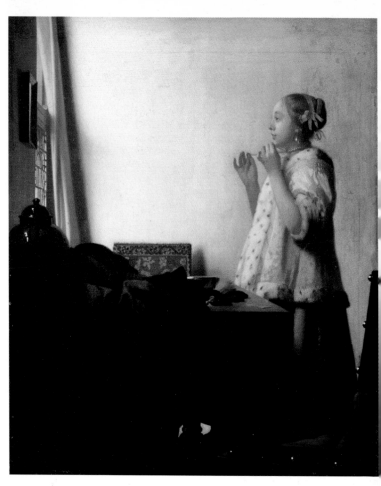

Woman with a Pearl Necklace, c. 1664. 21 ⅝ × 17 ¾ in (51.2 × 45.1 cm). Gemäldegalerie, Berlin.

■ Pearls

Around women's necks, on their ears or in their hair, pearls are Vermeer's preferred article of jewelry. The artist enjoys working with the pearl's contradictory symbolic values, letting the context of each scene contribute to a meaning. In the Catholic *Allegory of Faith** the pearl necklace may symbolize the sky, as interpreted in the Gospel of Saint Matthew (7:6–12:46), or faith, Christ or his Word. One's first impression of the woman at her dressing table holding a string of pearls to her neck before a mirror in *The Pearl Necklace* is that the painting depicts a scene from daily life. But in the *vanitas* tradition the necklace signifies futile and fleeting beauty and the mirror and vanity objects symbolize the ephemeral nature of worldly beauty.

Perhaps this is the meaning of the pearl necklaces worn by the women in love scenes, writing or receiving letters* or absorbed in music.* But doesn't Vermeer simultaneously celebrate their beauty by comparing the women to pearls, a common metaphor in romantic literature? Devoid of context, the pearl earrings in *The Girl with the Pearl Earring** (page 66–7) and *Portrait of a Young Woman* (Metropolitan Museum of Art, New York), would seem to have no other meaning. OZ

■ Porcelain in Delft

The first porcelain maker in Delft arrived from Antwerp in 1581 and worked mainly on tin-enameled platters and varnished tiles with polychrome decoration. Those who came to Delft to compete with him over the next twenty years produced the same sort of items. The famous blue and white porcelain known as Delftware (or *Hollands Porceleyn*, in Dutch) appeared in 1625, an imitation of Wan Li and Ming porcelains whose importation from China was interrupted due to disturbances within that country.

In 1670 there were some twenty workshops producing it, employing more than 1,600 workers; five to six percent of the population of Delft at the time. Delft's ceramic industry managed to escape the economic decline experienced by the city in the 1660s. Its relationship with the artistic community is not well documented, although no painter of talent seems to have been involved. Frederik van Frijtom, the most distinguished artist to have applied his talents to porcelain surfaces, never enrolled with Saint Luke's Guild.*

Vermeer reproduced Delftware tiles in several of his paintings, usually as friezes at the bottom of walls (*The Milkmaid**). GC.

■ Prostitution

To the great irritation of its many morally high-minded inhabitants, there was much prostitution in the Dutch United Provinces. Prostitutes and their clients were common sights in brothels, taverns* and the shady public houses called Stille Huyzen. From time to time authorities cracked down on the seedier sections of towns, imprisoning the women. Such establishments mainly flourished in port towns such as Amsterdam and Rotterdam.

Meanwhile, the upper bourgeois classes had their own parallel forms of prostitution, especially in The Hague. Prostitution became a sort of acceptable outlet in this society because moral pressures were great and extramarital sex was considered disgraceful.

Dutch painters enjoyed representing the inverse image of the clean and ordered universe of the bourgeois family preached by the moralists—and also represented by some of the same painters themselves. This world is seen clearly in Vermeer's *Procuress* (page 106), where, under the watchful eye of the procuress, a man shows a woman a coin with one hand while placing his other hand on her breast. Dirck van Baburen's *Procuress Scene* hangs on the wall in two of Vermeer's paintings, *The Concert* (page 51) and *A Lady Seated at the Virginal* (page 39), suggesting an association between profane music and other sensual pleasures. OZ

A Lady Standing at the Virginal (detail), c. 1672–73. National Gallery, London.

The Procuress (detail), 1656. Gemäldegalerie, Dresden.

PROUST, MARCEL

Marcel Proust (1871–1922) included numerous references to painting in his *Remembrance of Things Past*. The "little patch of yellow wall" passage from *The Captive* is probably the best-known among them. It concerns Bergotte, an esthete admired by the narrator Marcel, who despite being gravely ill, goes to an exhibition to see the *View* of Delft*, "the most beautiful painting in the world." Contemplating the painting's breathtakingly fine detail, Bergotte has a revelation of the essence of art that he sought to achieve in his own work, and dies before the Vermeer.

Here Proust embroiders on his own experience. Like Bergotte, Proust discovered Vermeer through his art critic friend Jean-Louis Vaudoyer, who went with him to the 1921 Paris exhibition of Vermeer. Proust's enthusiasm for this "barely identified painter" significantly contributed to Vermeer's new-found glory. GC

Marcel Proust leaving the Vermeer exhibition, Paris, 1921.

Religious Tolerance and its Limits

The Union of Utrecht (1579), the founding act of the Dutch Republic, also made Calvinism* the quasi-official religion. In the next century, while members of the reform religion probably comprised a majority of the population, they were nevertheless divided. Arminians (or Remonstrants) and Anabaptists accounted for a large and often influential portion of the population, especially among the patriarchate. Lutherans also sought to organize communities and set up churches. In Delft,* the landscape painter Adriaen Pietersz van der Linden was a Lutheran pastor and a member of Saint Luke's Guild. The Jewish community resided mainly in Amsterdam and numbered some 20,000. The remaining 20–40 percent of the population was Catholic. Tolerance in Holland was real, and it was facilitated to a certain extent by the independence of each province and often of particular cities with regards to religious questions.

But there were limits. Jews and Catholics were tolerated, but their worship had to take place behind closed doors: the sound of their worship was prohibited from public places. Thus religious prayers could not be heard from the street, and since they could not exhibit outward

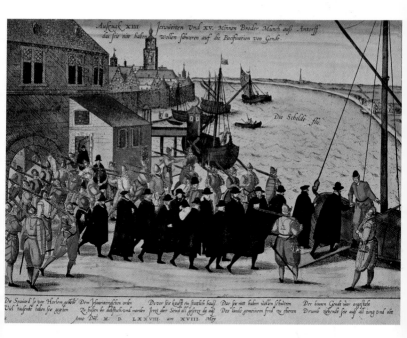

Franz
Hogenberg,
*Expulsion of
the Jesuits from
Antwerp,
May 1578.*
Engraving from
the Geneva
Public and
University
Library.

signs of faith, proselytism was necessarily prohibited as well. Only members of the reformed church were permitted to hold public office. Some Catholics, while strongly patriotic, sought peaceful reunification with the southern, still Spanish-held, provinces, because they thought this could bring religious parity. Arminians and Anabaptists suffered the worst persecution as representatives of a schism within the Reform Church. OZ

Rembrandt and his Workshop

In contrast to Vermeer, who painted in an upstairs room of his own home, Rembrandt van Rijn was a "master" in the traditional sense, establishing a school which ensuredthe diffusion of his personal style and widespread attention to his work. Rembrandt spent a great deal of time in his large studio located in a warehouse, surrounded by thirty or more students at any given point. Wooden partitions were put up to allow the pupils to work with a measure of privacy. Rembrandt schooled his disciples, instructing them to reproduce ancient and modern works, most often from his own drawings rather than originals, and organizing skits in which the apprentices play acted in order to better comprehend the passions and actions of the figures they represented. Some of Vermeer's early paintings, for example *The Procuress* (page 106), appear to have been influenced by Rembrandt. It is, however, unlikely that Vermeer ever set foot in Rembrandt's studio, and it would seem that students of Rembrandt who came to Delft* from Amsterdam at mid-century, such as Carel Fabritius (see Vedutisti), transmitted their master's lessons to Vermeer. GC

Reputation

Until his rehabilitation in the nineteenth century, Vermeer was considered an unrecognized genius in his own time. While this is the way in which Vermeer's reputation is often explained today, it requires some clarification.

Vermeer was in no way ignored by collectors of his time. Some of his paintings were purchased at considerable prices (see Art Market). And twice he was elected a headman of Saint Luke's Guild. His first election in 1662 even took place when he was quite young. After Fabritius' death (see Vedutisti) he was Delft's most admired painter. In 1669 a collector called him a "famous painter" in his personal journal. Having produced a small number of paintings—many of which were attributed to Gabriel Metsu,* Frans von Mieris* and Pieter de Hooch —he came to be given less attention than artists who painted more. Still, his reputation was solidly established in the nineteenth century. Étienne Joseph Théophile Thoré-Bürger's (1807–1869) article in the *Gazette des Beaux-Arts* presented the first detailed catalog of Vermeer's work, in 1866. Numerous writers, such as Théophile Gautier and Marcel Proust,* fell under his spell and considered him a genius.

The catalog of Vermeer's paintings was continually improved over the course of the twentieth century, and his iconic status affirmed in a variety of ways. For instance *The Milkmaid** has been used as a symbol for a dairy-produce company. GC

Caricature of E. J. T. Thoré-Bürger, 1866.

Reynier Vermeer
The painter's father

Reynier Janz Vermeer was born in Delft* in 1591 to a Protestant family (see Calvinism) in the popular market section of town. His mother's second husband was a musician; Janz is a patronymic, meaning son of Jan. He was apprenticed in Amsterdam to a weaver of caffa, a rich fabric popular at the time. In 1615, while still in Amsterdam, he married Digna Baltens, whose father was originally from Antwerp. When he returned to Delft he continued weaving caffa. An inventory of his belongings dating to 1623 reveals that he already owned several paintings— probably copies. The first painting mentioned represents a figure playing a shepherd's pipe, a typical Caravaggian* theme, and a topic that may relate to Reynier's stepfather's profession. Upon his death Reynier's stepfather had left him a sort of flute, an instrument that Reynier himself may have played.

Reynier continued to work with caffa, even after he began work in the inn he rented towards

Rembrandt (1606–1669), *Abraham's Sacrifice of Isaac,* 1636.
6 ft 4 ¾ in × 4 ft 4 in (1.95 × 1.32 m). Alte Pinakothek, Munich.

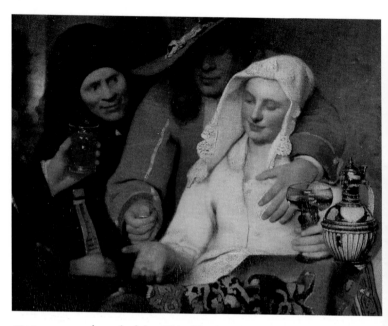

The Procuress
(detail), 1656.
Gemäldegalerie,
Dresden.

*Mistress and
Maid,*
c. 1667–68.
35 ¼ × 31 in
(90.2 ×
78.7 cm). The
Frick Collection,
New York.

the end of the 1620s. The inn was located in the Voldersgracht district. It bore the sign "Flying Fox," and Reynier temporarily adopted the family name of Vos, which means fox. Sometimes he also called himself Vermeer. He was signed up with the guild* in 1631 as an "art dealer." The extent of his commercial gains* in this field seems to have been modest, compared to more considerable Delft art merchants, such as Abraham de Cooge (see Buying and Selling Paintings.)

His son, the future artist, was baptized in a reform church on October 31, 1632. The choice of the name Johannes is significant in that such a Latinate form was popular among Catholics and upper-class Protestants. In this way it marked a change in the family's social position. Reynier's rising status was accompanied by his purchase of the Mechelen Inn, one of the most impressive houses on the Great Market

Square. Since his clientele included people from the middle classes, artists and art collectors, the exchanges which took place there concerning artistic matters probably provided a favorable atmosphere for young Johannes Vermeer. Reynier died in 1652; Digna Baltens in 1670. CaG

■ Self-portraits

No Vermeer self-portrait exists, at least not in the precise sense of the term, since he left no paintings or drawings with such a title. Efforts have been made to identify the artist with *The Geographer* (page 17) and *The Astronomer.** But what he actually looked like is probably not as important or interesting as the clues he left about himself in his works.

The figure on the left in *The Procuress* (page 106) is the most likely candidate as a self-portrait. The way this person is slightly set back from the principle action with his face

turned to the viewer conforms to conventions used by artists since the Renaissance, when they placed images of themselves in their work. The same figure, wearing the same costume, can also be seen in *The Art* of Painting*, although in the latter case he is seen from behind, with his face and there-fore his identity concealed. Nothing really indicates that this is Vermeer. It simply shows the ideal presence of an artist in the work. This presence becomes more symbolic in *The Music Lesson* (page 89). There too, people have thought they saw an image of the artist. But once again, the artist is else-

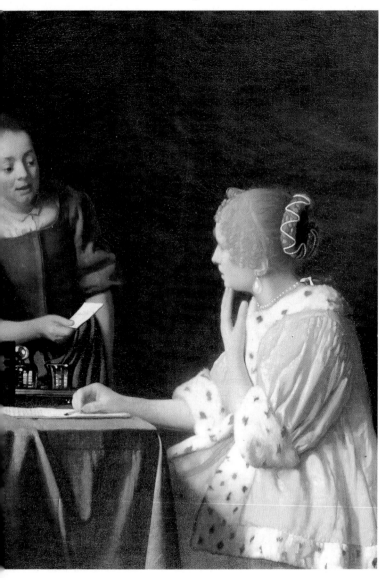

where. The easel reflected in the mirror above the woman's head evokes the artist's existence outside the painting. At the same time, the young man's loving gaze upon the young woman creates a sort of relay system for the viewer's gaze, perhaps suggesting the painter's view of his painting as a loving look upon painting itself. CaG

■ Servants

Female domestic servants are important figures in Dutch interior* representations. Every bourgeois household had at least one in its employ. Paintings portray them at their daily tasks, hanging the washing, sweeping, washing dishes, etc. *The Milkmaid* (page 86–7) presents a household scene of this sort. Servants are also representatives within the family environment of the outside world

and its vices and defects. Maid-servants often represent laziness and the dangers that ensue from this defect of character. Nicolaes Maes' *Idle Servant,* also known as *The Sleeping Maid* (National Gallery, London) pointedly exhibits a cat taking advantage of a hired maid who has fallen asleep at work.

Serving maids serve primarily as connecting figures in Vermeer's paintings. They form the link between the world at large and the private domain, and between men and women. Vermeer's maidservants are essentially charged with tasks relating to amorous liaisons. They bring letters, as in *Mistress and Maid* (page 103) and sometimes serve as confidantes, as in *The Love Letter.* GC

■ STILL LIFES
Inside Vermeer's Silence

The still life was a very successful genre in the Netherlands.* Its decorative value and low price made it popular and accessible.

It presents special conditions for artists in that the relative freedom of subject matter allows for concentration on the technical aspects of painting. An artist's sensibility comes to be expressed by the choice and organization of objects and compositional approaches. Thus painters offer up descriptions of their experience of the beauty of the visible world, particularly fixing their attention on how variations in light* may affect the representation of objects. The materiality* of objects, their surfaces, texture, grain, and even their internal parts are presented. The same sort of genre of specialization (see Genre Distinctions) that occurs in other genres can be seen in still lifes, which include table settings, bouquets, fruit baskets, fish, shells, game, etc. And each painter presents particular specialties, whether in the representation of shiny fish scales, reflections of light on glass or metal, or the silky fragility of flower petals. still life canvases seem strangely alive. This is partly a result of their illusionistic effects. They are also meant to fool the viewer. What one takes as reality is merely appearance. Images are merely enticements, and painting is merely another vain pursuit. CaG

A Maid Asleep
(detail),
c. 1657. The
Metropolitan
Museum of Art,
New York.

Sweerts, Michael

It is known that Michael Sweerts was baptized in the Saint Nicolas Church in Brussels in 1624, but many other details concerning his life are as obscure as those relating to Vermeer's. Like Vermeer, Sweerts seemed to have been forgotten for a long period, and many of his

whose principal representative in the Netherlands was Pieter van Laer.

Sweerts's repertoire includes as many head and shoulder portraits as genre paintings that include both half-figure depictions (*Young Man and Procuress*, below) and outdoor scenes akin to the work of van Laer.

Michael Sweerts
(1624–1664),
*Young Man
and Procuress.*
6 ft 10¼ in ×
8 ft 10¼ in
(1.90 × 2.70 m).
Musée du
Louvre, Paris.

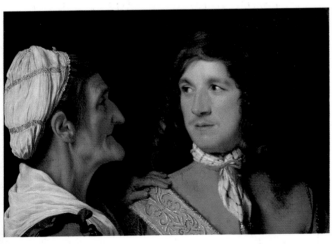

works were misattributed. The great originality of this artist who spent at least eight years in Rome (from 1646–54), has only recently been the object of critical attention. Sweerts was strongly influenced by Caravaggio and the Bamboccianti,

The light* that gives off from figures generally in front of dark backgrounds, and their intense stillness (*The Spinner*, Stedelijk Museum, Ghent, Gouda), renders his work comparable to Vermeer's. Vermeer may have seen some of Sweerts' paintings

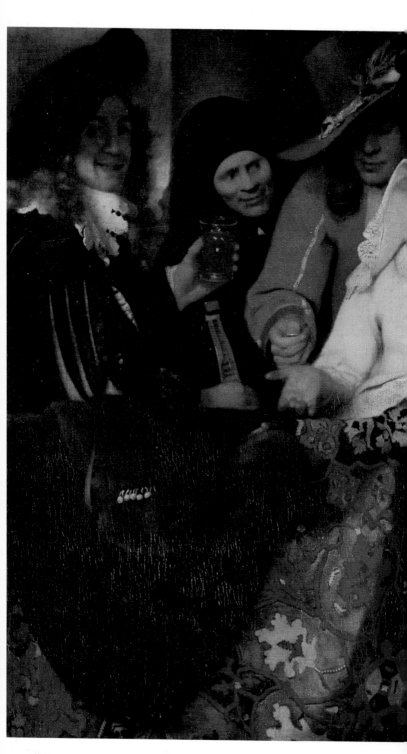

in Amsterdam. In addition to particularly strong stylistic affinities, the two artists shared the ideal of conferring classical dignity upon scenes of daily experience. PLC

The Procuress, 1656. 56⅛ × 51⅛ in (1.43 × 1.30 m). Gemäldegalerie, Dresden.

■ Taverns and Sex

Allusions to prostitution* and debauchery are fundamental elements of genre* painting. What was often more or less concealed behind elegant technique and elegant figures was often quite clearly manifest in tavern and brothel scenes. The difference was in the treatment and approach rather than the subject matter itself, for the intention behind tavern and brothel scenes could not be more apparent. They aimed at moral edification. Rather than offering an image of serene and pleasant enjoyment, the viewer was meant to be warned against petty occupations and superficial pleasures. Paintings with drinkers and women doing their toilet belong to this category of representation. For instance, intoxicated sleep can lead to laziness (*A Maid Asleep,* page 28–9) and the voyeuristic aspects of viewing a woman at her toilet are often used to allude to the activity of prostitutes.

So these paintings are both salacious and morally instructive. Some of the objects of the décor are obvious sexual metaphors that lead crudely enough to conclusions for which a particular tableau presents only the preliminaries: oysters, gallants offering or accepting drinks, transactions between madams or prostitutes and their clients, and so on. The Reformed Church forbade the playing of music,* an activity often depicted in genre scenes. CaG

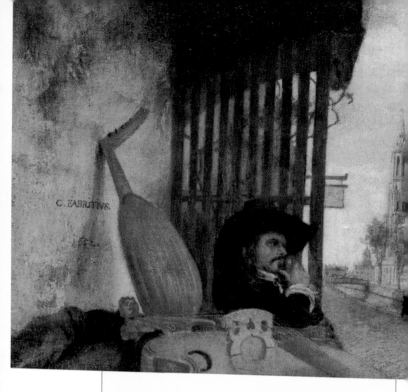

▨ VEDUTISTI

Vedute are landscape and town views, sometimes extending to the representation of interiors. Painters of such views are called *vedutisti*. City and church interiors were a specialty of Dutch painters of this genre. After the cityscapes of the beginning of the seventeenth century that still manifested a dreamy mannerist style, and the urban silhouettes on the horizons of the Haarlem school's landscapes, painters began taking inspiration from topographic drawings in the middle of the century to create increasing numbers of emblematic and typical city views. In Amsterdam, Jan and Abraham Beerstraaten developed a meticulous style. In Haarlem, Gerrit Berckheyde's paintings brought the genre to an apogee, with a more monumental approach which at the same time developed contrasts between extremely high-lit and deeply shadowed areas. The success of Egbert van der Poel and Daniel Vosmaer was in large part due their representations of Delft after the Great Gunpowder Explosion of 1654 in which Fabritius* was killed. Fabritius was the author of a remarkable view in Delft (above), presenting two vanishing points.

Gerrit Houckgeest's arrival in Delft led to the development of a group of artists whose paintings represented the interior of churches. Houckgeest broke with the frontal approach favored by the Haarlem artist Pieter Saenredam, and organized his paintings along diagonals in two-point recession. Emmanuel de Witte imitated Houckgeest, but bathed his interior in softer Vermeer or Fabritius-like light.* OZ

Carel Fabritius (1622–1654), *View in Delft, with a Musical Instrument Seller's Stall.* 1652. 6⅛ × 12⅜ in (15.5 × 31.6 cm). National Gallery, London.

Romÿn de
Hooghe
(1645–1708),
*The death of the
de Witt brothers,
Jean and
Cornelius, killed
in The Hague
during riots
when French
troops arrived
in Holland.*

■ War of 1672

In the middle of the seventeenth century France and England began to feel threatened by the system of government and the independence of the Dutch Republic (see Netherlands).

The Treaty of Westphalia of 1648 marked the end of Holland's war with Spain and an important moment in its energetic commercial activities. But Louis XIV saw the Netherlands' commercial strength as cause for declaring war against them, as did England, which followed France's example. Louis XIV's war against what he called "the insolence of the Dutch" was short, but disastrous for the Republic, whose losses in territory and money were great. It also brought the selling of paintings to a halt. Painters were hit hard. Vermeer was directly affected, and apparently died (according to Catharina Bolnes*) following the financial collapse that ensued from these events. GC

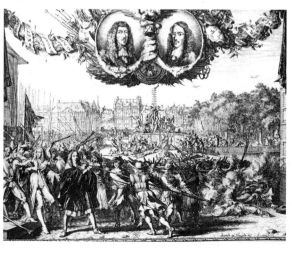

◾ VIEW OF DELFT

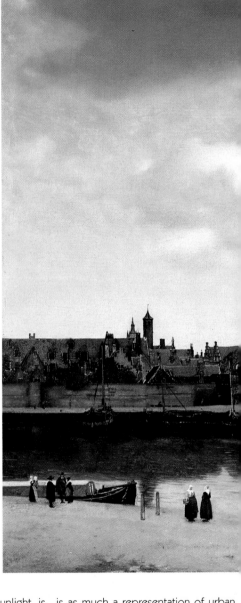

Marcel Proust's passage about the "little patch of yellow wall" endows Vermeer's *View of Delft* with a mythical aura that directs the spectator's gaze in search of the astonishing detail.

The exterior scene is a rare subject for Vermeer, and only after attempting it on a small scale in *The Little* Street,* does the artist take on a full city view, a whole separate genre linked to topographic painting and the urban panoramas on older large format Netherlands* wall maps.* Municipalities and sizeable towns customarily commissioned views of their area. Vermeer represents his native city in this painting. It is seen from the south, following the examples of van Goyen's The Hague and Rembrandt's* Amsterdam (see Local Centers of Activity). The main buildings of Delft are clearly recognizable: behind a row of houses to the left is the Old Church where Vermeer is buried. The New Church, drenched in sunlight, is just to the right of the little bridge, and the Rotterdam Gate with its two towers is easy to spot. Vermeer's attention to detail extends to the representation of climatic variations and the play of light* over the city. The *View of Delft* is as much a representation of urban life as a landscape of light. The painter marks the exact time of this pictorial snapshot on the Schiedam Gate clock: 7:10 in the morning.

Rather than attempting to depict what the naked eye can see, Vermeer com-

poses what Roland Barthes called a "reality effect." The city is lengthened, certain houses are regrouped, and their sizes are altered to lend Delft the form of a perfect frieze. X-rays show that Vermeer, exaggerated the towers' reflection to the right in order to compensate for the view's frontal presentation. GC

View of Delft, 1660–61. 38¾ × 46¼ in (96.5 cm × 1.16 m). Mauritshuis, The Hague.

Girl Reading a Letter at an Open Window (detail), c. 1659. Gemäldegalerie, Dresden.

The Girl with Two Men or *The Girl with the Wine Glass,* 1659–60. 30¾ × 26⅜ in (77.5 × 66.7 cm). Herzog Anton Ulrich-Museum, Brunswick.

Vermeer's use of windows is one of the particularities of his treatment of interior* scenes. Gerard ter Borch rarely painted windows, and Pieter de Hooch usually presented landscape views through them. Vermeer's windows present light* itself, revealing nothing else from the exterior world. He used them to create the effect of light on rugs, walls and maps,* and even from his earliest genre paintings,* Vermeer's windows are important for the creation of his luminous color scheme.

Windows also mark the intersection of the inside and the outside world. Figures direct their gaze towards them for different reasons (*The Geographer*, page 17, and *Woman with a Lute*, page 20). Windows, like letters,* establish relationships across distances, they are transmission points for the absent lovers about whom these women are thinking (*Lady Writing a Letter with her Maid*, page 24–5). GC

■ Windows

Windows are more than simple details in Vermeer's paintings and in Dutch interior painting in general. While they may be of little interest in themselves—for instance as architectural elements of Dutch buildings of the period—they are essential elements in Vermeer's system of composition. Sometimes he covers them with curtains or situates them outside the main visual field (*Girl Reading a Letter at an Open Window*, page 74–5), and sometimes he decorates his windowpanes, as in the emblem of *The Glass of Wine* (page 62–3), and the symbol of temperance in *The Girl with Two Men,* also known as *The Girl with the Wine Glass* (facing page).

■ Wine

The glass of wine is a common detail in tavern* and brothel scenes where the figures, under the influence of tobacco and alcohol, partake in sexual excesses. The refinement of the genre* scene in the 1650s led to the rejection of trivial connotations, allowing for only a few indications of sensuality in human interaction. The glass of wine was foremost among these chosen symbols, along with musical instruments, which are often related in the new style of erotic anecdote.

The only instance of a man drinking in a Vermeer painting is in *The Procuress* (page 106).

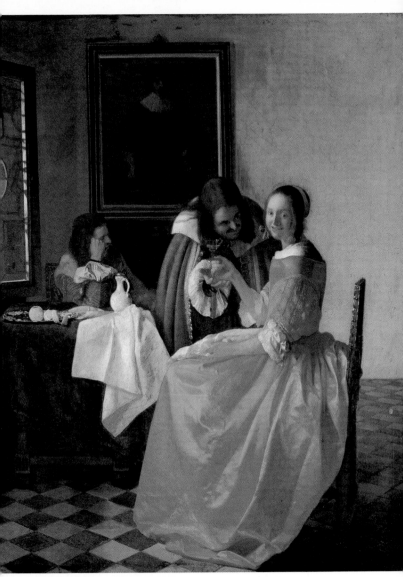

According to convention, wine is always presented to the woman by the man, breaking the social ice as a prelude to amorous relations. In *The Girl with the Wine Glass,* also known as *The Girl with Two Men* (above), the woman's drunken regard cast upon the viewer tells all about wine's immoral role. Across from her, the stained glass window depicts Temperance. Wine is also seen to lead to domestic disorder causing servants to sleep with the house unattended, as in Nicolaes Maes' *The Sleeping Maid* paintings, or more subtly in Vermeer's *A Maid Asleep* (page 28–9). GC

"It is the vividness, the energy, the perfection, the variety, the unexpected, the oddity, the inexplicably rare and the compelling."

E. J. T. Thoré-Bürger, 1866

■ WOMAN HOLDING A BALANCE

This painting was formerly known as *The Woman Weighing Gold*. It depicts a classic theme in Dutch painting that Vermeer subtly transforms into a personal expression freed from genre conventions. A woman stands before a table holding precious objects, including two open boxes containing strands of pearls.* She wears a blue jacket trimmed in white fur, a variation on the yellow satin and white fur jackets mentioned in the painter's inventory and often represented in his work. Holding scales, the woman faces a mirror, often symbolic of Prudence and Truth. Behind her is a painting of the Last Judgement.

While generally considered to be an allegory, the *Woman Holding a Balance* has inspired many interpretations. She appears to be pregnant, and might be seeking to determine, in accordance with popular custom, her child's sex. The image has often been considered one of vanity: a woman weighs her material wealth, unconcerned with the Last Judgement that awaits her. Careful study of the canvas has determined that the scale holds nothing, placing an emphasis on the process of weighing the possibilities or balance in perfect equilibrium. Vermeer skillfully painted the background picture frame lower on the left than on the right, bringing the scale to the fore.

Period emblem books often represent women holding scales as a symbol of Truth. In accordance with this tradition, this woman before a mirror would be weighing her actions. She might also stand for a Catholic critique of the Protestant theory of predestination. GC

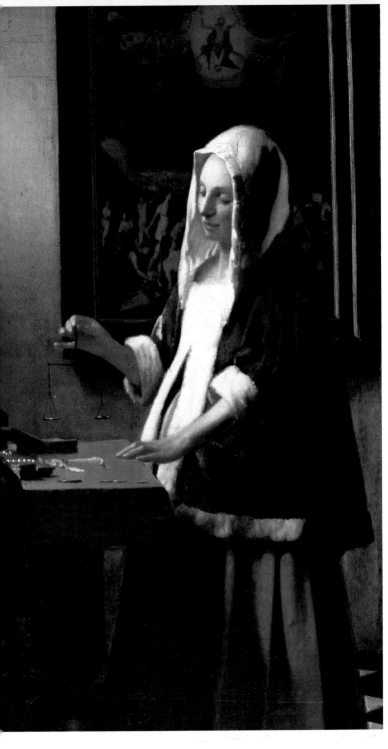

Woman Holding a Balance, c. 1664. 16¾ × 15 in (40.3 × 35.6 cm).
National Gallery of Art, Washington, DC.

1632 October 31. Baptism of Johannes Vermeer, second child and first son of Reynier Vos, baptized at Nieuwe Kerk, the New Reformed Church of Delft. Spinoza and Anthony van Leeuwenhoek are born the same year.

Van Leeuwenhoek's achievements include improving the microscope, discoveries concerning red blood cells, and description of spermatozoids. He may have known Vermeer and discussed his research into optics with the artist. Van Leeuwenhoek would be named executor of Vermeer's estate in 1676 by Vermeer's wife, Catharina Bolnes.

1641 April 23. Vermeer's father buys "Mechelen" a house and inn leading onto the Great Market Square in Delft. In tandem with his inn-keeping, Reynier Vos sets up as an art dealer, taking on the name Vermeer. He establishes close ties with a number of major Delft painters, whose work he handles.

1642 Rembrandt paints *The Night Watch* (Amsterdam).

1645 Gerard ter Borch goes to Munster to paint the portraits of numerous diplomats at the Treaty of Westphalia (1648) which ends the Thirty Years' War and eighty years of war between the Dutch and Spain, and ratifies Spain's recognition of the United Provinces of the Netherlands.

1653 April 20. Vermeer and Catharina Bolnes are married. Catharina's mother, Maria Thins, disapproves and almost forbids their union. Vermeer's Calvinist family bears the disgrace of debt and a money-counterfeiting grandfather. Catharina Bolnes' family is well-off and devoutly Catholic. Vermeer converts to Catholicism shortly after his marriage.
April 22. Vermeer and ter Borch sign a notarized act in Delft.
December 29. Vermeer becomes a member of Saint Luke's Guild of Delft.

1654 October 12. The Delft gunpowder depot explodes, taking the life of Carel

Fabritius, a student of Rembrandt and one of the best-known Delft painters. In 1668 Arnold Bon publishes a work on Delft in which Vermeer is described as being born phoenix-like from the flames that consumed Fabritius.

Pieter de Hooch settles in Delft until 1662, when he leaves for Amsterdam. He makes a significant impact on genre painting in general and Vermeer's work in particular. Painter and writer Samuel van Hoogstraten executes the first documented trompe l'œil painting. He later constructs a perspective box containing a painted view of a Dutch interior.

1655 Vermeer paints his first recorded work, *Diana and her Companions* (Mauritshuis, The Hague).
In the early years of his career, Vermeer earns little money and his mother-in-law provides financial support.
December 14. Vermeer and his wife sign as guarantors for a 250 florin debt contracted by the artist's father in 1648. Vermeer is referred to as "sir," a sign of his social rise.
Pieter de Hooch enrolls in Saint Luke's Guild of Delft.
Like others of his generation, Gabriel Metsu abandons history painting for genre scenes.

1656 Vermeer signs and dates *The Procuress* (Gemäldegalerie, Dresden). The male figure facing the viewer may be a self-portrait.

1658–62 Vermeer paints his best-known works:
View of Delft (Mauritshuis, The Hague), *The Milkmaid* (Rijksmuseum, Amsterdam), and *The Music Lesson* (Buckingham Palace, London).

1662 October 18. Saint Luke's Day. Vermeer is elected a "headman" of the Saint Luke's Guild for a two year period. He is the youngest representative.

1663–66 Vermeer is plagued with problems. His mother-in-law Maria Thins

complains of violence and threats from her son Willem, who batters the pregnant Catharina. Maria Thins has Willem placed under arrest. Vermeer's paintings bear no trace of domestic trauma.
Vermeer paints *Woman in Blue Reading a Letter* (Rijksmuseum, Amsterdam), *The Pearl Necklace* (Gemäldegalerie, Berlin), and *Woman Holding a Balance* (National Gallery of Art, Washington DC).

1667 Gabriel Metsu dies in Amsterdam.

1669 Rembrandt dies.
Vermeer paints *The Geographer* (Städelsches Kunstinstitut, Frankfurt), companion piece to *The Astronomer* (Musée du Louvre, Paris), completed the previous year.

1670 With nine or ten children to care for, despite some inheritance, Vermeer has difficulty making ends meet.
February 13. Burial of Vermeer's mother.
July 1. Vermeer inherits the Mechelen Inn. Vermeer is reelected guild representative.

1672 May. Vermeer goes to The Hague to advise the Elector of Brandenburg on the authenticity of a group of Italian paintings acquired from Amsterdam's major art dealer. The assignment is evidence of Vermeer's high reputation at the time.

The French invasion of the United Provinces leads to serious economic problems which have an impact on Vermeer. Following the artist's death his widow stated that he sold almost no paintings in its aftermath.
Assumed date of Vermeer's last work, *The Allegory of Faith* (The Metropolitan Museum of Art, New York).

1673 In a notarized act, Vermeer's mother-in-law grants him power of attorney.
The French withdraw from the United Provinces.

1675 December 16. Vermeer's funeral at the Old Church of Delft. He is survived by eleven children, eight of whom are minors. The name of his son Ignatius, in honor of the founder of the Jesuits, attests to the artist's devout Catholicism. Gerrit Dou dies in Leiden.

1676 February 29. Inventory of Vermeer's estate. In heavy debt, his widow sells twenty-six paintings to an Amsterdam dealer. She keeps *The Art of Painting* as a gift to her mother.

1678 Publication of Samuel van Hoogstraten's *Treatise on Painting*.

SELECTED BIBLIOGRAPHY

Gilles Aillaud, John Michael Montias and Albert Blankert, *Vermeer*. New York: Rizzoli, 1988.

Svetlana Alpers, *The Art of Describing: Dutch Art in the Seventeenth Century*. Chicago: University of Chicago Press, 1983.

Daniel Arasse, *Vermeer: Faith in Painting*. Princeton: Princeton University Press, 1994.

John Michael Montias, *Vermeer and His Milieu: A Web of Social History*. Princeton: Princeton University Press, 1988.

Simon Schama, *The Embarrassment of Riches: An Interpretation of Dutch culture in the Golden Age*. Berkeley: University of California Press, 1988.

Edward A. Snow, *A Study of Vermeer*. Berkeley: Univ. of California Press, 1994.

Jørgen Wadum, René Hoppenbrouwers and Luuk Struick van der Loeff. *Vermeer Illuminated. Conservation, Restoration and Research*. The Hague: Mauritshuis, 1994.

Arthur K. Wheelock, Jr. *Johannes Vermeer*. Washington: (Ex. Cat.), 1995.

Arthur K. Wheelock, Jr. *Vermeer and the Art of Painting*. New Haven and London: Yale University Press, 1995.

INDEX

Photographic credits: AMSTERDAM, Rijksmuseum 18, 68, 78, 80, 86; BERLIN, Gemäldegalerie 62, 84, 96; BOSTON, Isabella Stewart Gardner Museum 51; The Museum of Fine Arts 38; BRUNSWICK, Herzog Anton Ulrich-Museum, 113; DRESDEN, Gemäldegalerie 75, 97 bottom, 102, 106–7, 112; DUBLIN, The National Gallery of Ireland 25; EDINBURGH, The National Gallery of Scotland 15, 48–9; GENEVA, Public and University Library, 72, 99; HANNOVER, Niedersächsisches Landesmuseum 40; THE HAGUE, Royal Library 46; Mauritshuis 32–3, 41, 55, 66, 110–11; LEIDEN, Stedelijkmuseum « De Lakenhal » 52–3; LONDON, British Museum 54–5; Buckingham Palace 88–9; National Gallery 39, 44–5, 56, 70, 93–4, 97 top, 108–9; LYON, musée des Beaux-Arts 92; MUNICH, Alte Pinakothek 101; NEW YORK, The Frick Collection 10, 42–3, 83, 103; The Metropolitan Museum of Art 20, 28–9, 59, 61, 105 top; PARIS, Réunion des musées nationaux 12, 13, 14, 36, 47, 50, 64–5, 69, 76, 85 top, 90–1, 105 bottom; PRINCETON, The Barbara Piasecka Johnson Collection Foundation 82; PEISSENBERG, Artothek cover, 17; ROTTERDAM, Maritiem Museum Prins Hendrik 11; SCHWERIN, Staatliches Museum 85 bottom; VIENNA, Kunsthistorisches Museum 30, 34–35; WASHINGTON, The National Gallery of Art 21–2, 23, 79, 114–5.

Translated and adapted from the French by Stacy Doris and Chet Wiener
Typesetting: A propos / Julie Houis
Color separation: Pollina S.A., France

Originally published as *L'ABCdaire de Vermeer* © 1996 Flammarion
English-language edition © 2001 Flammarion Inc.

ISBN: 2-0801-0549-3
N° d'édition: FA0549
Dépôt légal: 02/01
Printed and bound by Pollina S.A., France - n° L83196

Page 4–5: *The Astronomer* (detail), 1668. Musée du Louvre, Paris.
Page 6: *Lady Writing a Letter with her Maid* (detail), c. 1670.
National Gallery of Ireland, Dublin.

FOREWORD

Golf Rules Illustrated is an excellent publication. The new edition is based on the latest version of the Rules of Golf which come into effect on 1 January 2016.

One of the important changes in the new Rules is the prohibition against anchoring the club, either directly or using an anchor point and this is clearly illustrated by helpful photographs.

This edition contains many clear diagrams and pictures and these are so valuable in bringing alive the somewhat complex language of the Rules themselves.

Throughout the book you will find helpful Q&A sections as well as many incidents drawn from real events. With interesting historical background and clear explanations of many prominent Rules issues, you can both learn and be entertained by this latest version of *Golf Rules Illustrated*.

David Bonsall
Chairman, Rules of Golf Committee
R&A Rules Limited

R&A Rules Limited
With effect from 1 January 2004, the responsibilities and authority of The Royal and Ancient Golf Club of St Andrews in making, interpreting and giving decisions on the Rules of Golf were transferred to R&A Rules Limited.

Gender
In the Rules of Golf, the gender used in relation to any person is understood to include both genders.

Golfers with Disabilities
The R&A publication entitled *A Modification of the Rules of Golf for Golfers with Disabilities* contains permissible modifications of the Rules of Golf to accommodate disabled golfers; it is available through The R&A.

Decisions
Reference is made throughout this publication to the *Decisions on the Rules of Golf*. The current edition of the *Decisions on the Rules of Golf* is available at www.randa.org.

PRINCIPAL CHANGES INTRODUCED IN THE 2016 CODE

Rules of Golf

Rule 3-3. Doubt as to Procedure

The Rule has been amended to provide further guidance on:

1. The procedure for a competitor who is uncertain of how to proceed and decides to play two balls; and
2. How the Committee should determine which ball is to count in such situations.

In addition, the Rule has been expanded to provide guidance on which ball counts when the Rules do not permit the procedure used for either ball.

Exception to Rule 6-6d. Wrong Score for Hole

This new Exception provides that a competitor is not disqualified for returning a score for any hole lower than actually taken when this is due to a failure to include one or more penalty strokes that, before returning his score card, the competitor did not know he had incurred. Instead, the competitor incurs the penalty prescribed by the applicable Rule and an additional penalty of two strokes for each hole at which the competitor has committed a breach of Rule 6-6d.

Rule 14-1b. Anchoring the Club

A new Rule is introduced to prohibit anchoring the club, either "directly" or by use of an "anchor point", during the making of a stroke.

Rule 14-3. Artificial Devices and Unusual Equipment; Abnormal Use of Equipment

Several amendments have been made to Rule 14-3, including:

1. A statement of principle has been introduced to confirm what guides the governing bodies in determining whether use of any item is a breach of Rule 14-3;
2. For clarity, the previous reference to "unusual use of equipment" has been changed to "abnormal use of equipment"; and
3. The penalty for a player's first breach of Rule 14-3 during a stipulated round has been modified from disqualification to loss of hole in match play or two strokes in stroke play, with disqualification applied as the penalty for a subsequent breach of the Rule.

Rule 18-2. Ball at Rest Moved By Player, Partner, Caddie or Equipment

Rule 18-2b (Ball Moving After Address) has been withdrawn. This means that when a ball moves after a player has addressed it, the application of a penalty under Rule 18-2 will be based purely on whether the player caused the ball to move.

Rule 25-2. Embedded Ball

Notes have been introduced to:

1. clarify when a ball is embedded; and
2. confirm that a Committee may introduce a Local Rule allowing relief without penalty for a ball embedded anywhere through the green.

Rule 26-2. Ball Played Within Water Hazard

The Rule has been reformatted solely for clarity. There has been no substantive change.

Appendix I. Local Rules; Conditions of the Competition

Former Parts A and B of Appendix I relating to Local Rules are consolidated to provide all of the pertinent information on specific Local Rules in a single location.

Appendix IV. Devices and Other Equipment

Part 5 relating to distance-measuring devices is amended so that, when a Local Rule permitting the use of distance-measuring devices is in effect, there is a breach of Rule 14-3 only if a player uses the device for some other purpose that is prohibited by that Rule. Previously, when the Local Rule was in force, a player was in breach of Rule 14-3 if he used a distance-measuring device that also contained other features whose use would breach Rule 14-3, regardless of whether such other features were actually used by the player.

Appendices II, III, IV

Statements on equipment conformance and product submission processes were removed from Rules 4, 5 and 14-3 to eliminate redundancy with Appendices II, III and IV. The revision to consolidate these statements in the Appendices is non-substantive and done solely for efficiency.